IMAGES
of America

BROOKINGS

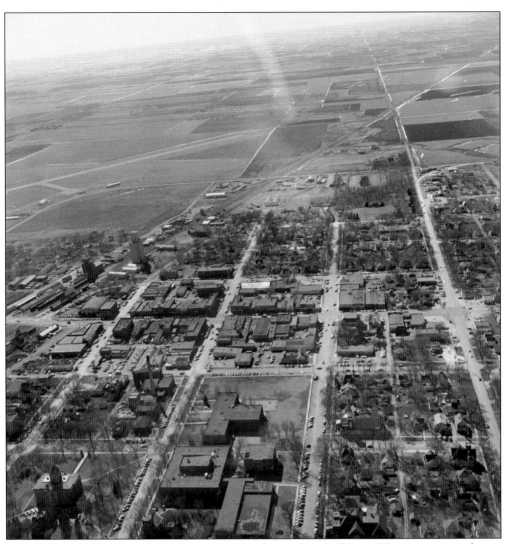

This 1950s aerial photograph shows many of Brookings's best buildings. The county courthouse is visible in the lower left-hand corner. To the right of the courthouse are Brookings's schools: the old middle school, the old grammar school, and Central Elementary. All of Main Avenue is also visible from Sixth Street to the railroad tracks. (SDSU Archives.)

On the Cover: In this 1953 photograph, a Bibby's deliveryman is getting ready for his daily route. Milk deliverymen worked early mornings and traveled many miles on their routes to make sure every customer was happy. (SDSU Archives.)

IMAGES
of America

BROOKINGS

Colleen Zwieg Poindexter
with the support of the
Brookings Historic Preservation Commission

ARCADIA
PUBLISHING

Published by Arcadia Publishing
Charleston SC, Chicago IL, Portsmouth NH, San Francisco CA

Printed in the United States of America

Library of Congress Control Number: 2010922905

For all general information contact Arcadia Publishing at:
Telephone 843-853-2070
Fax 843-853-0044
E-mail sales@arcadiapublishing.com
For customer service and orders:
Toll-Free 1-888-313-2665

Visit us on the Internet at www.arcadiapublishing.com

For my mother, Diana Zwieg,
and for my aunt, Judy Hauff,
who sought an outlet for my creativity.
I also dedicate this to my husband, Brian Poindexter.

CONTENTS

ACKNOWLEDGMENTS

Any project of this scope requires the generous help of many individuals whom I wish to thank. I first must thank my parents, Diana and Larry Zwieg, my aunt Judy Hauff, and fellow author Richard Popp for their advice. I also want to thank Jerry McCullough, Shari Thornes, and the Brookings Historic Preservation Commission for their support and guidance.

My sincerest thanks and gratitude goes to Stephen Van Buren and the archives department at the Briggs Library at South Dakota State University (SDSU). They compiled a large portion of the photographs presented in this book, and Stephen was very generous with his time.

Thank you to Dawn Stephens and the South Dakota State Agricultural Heritage Museum for their help. Also I want to thank Howard Lee and the Brookings County Museum for unlimited access to their collection. Additionally, I must thank Deanna Rude for lending me her collection of postcards and photographs.

Many other community members generously gave of their time, personal photographs, and funding to ensure the completion of this project. Thank you to all of those individuals who helped: Pat and Bob Fishback, Barbara and Van Fishback, Fishback Financial Corporation, Scott and Deb Dominiack, Donna Ramsay, Doris Roden, Diana Ammann, Jerry and Shirley Bergum, M. K. and Ernie Hugghins, Alfred and Deanna Rude, Ron and Cheryl Deutsch, Hank and Marcia Williams, Tom and Jeanne Manzer, Orville and Charollet Smidt, Fred and Ardyne Rittershaus, Barbara Hoium, Dan and Michele Kemp, Richard and Donna Wilson, Country Peddler, David and Linda Beulke, Gary and Carol Omodt, Del and Judy Johnson, Harry Mansheim, and Rick and Bonnie Salonen.

INTRODUCTION

Brookings County lies entirely upon the Coteau des Prairies, an elongated plateau that prominently rises above the interior lowland plains and stretches from Sioux Falls to the North Dakota border. There are many places throughout the county where one can stand and see for miles around.

This area of the state was inhabited by Native Americans well into the late 1800s. A federal census in 1840 estimated that 25,000 Native Americans were living in the Dakotas. While there were no whites permanently living in the area, there were fur traders who traveled through the area and even lived among the natives. The beginning of Brookings can be traced back to a settlement named Medary, which the Dakota Land Company of St. Paul started by the Big Sioux River in 1857. A few years earlier, the Eastern Sioux Tribe had signed a treaty in which they gave up all of the land east of the Big Sioux River, including what would be Brookings County. While the initial settlers of Medary tried to peacefully coexist with the Native Americans living in the area, the settlement was eventually abandoned in June 1858 when a Native American uprising ran them out. Nearly 10 years later and roughly 4 miles to the north of the Medary settlement, the beginnings of Brookings could be seen.

One of the key elements in developing Brookings was the arrival of the railroad. Early Brookings businessman William Henry Skinner arrived in the area in June 1873 and is responsible for bringing the Chicago and Northwestern Railroad to Brookings. Skinner bought 240 acres of land, secured the railroad to come, and then advertised the town of Brookings, making it known that he had several acres of town lots to sell.

Brookings became an official town when it was platted in 1879 and named after Wilmont W. Brookings, a prominent land company developer. The first city officials for Brookings were elected in May 1881 and consisted of the men who helped develop the area. R. S. Hadley was the first mayor, George Morehouse was the treasurer, and the first councilmen were R. H. Williams, Horace Fishback, and George A. Mathews. As a first step to turn the village into a city, officials passed an ordinance in May 1882 that livestock could not "run at large" within the corporate limits of Brookings.

Brookings began expanding quite rapidly after it became apparent that the railroad would be bringing supplies and business to town. The 1877 census of Brookings County indicated that less than 250 people lived in the area, but by 1885 the state census counted 8,288 people. By May 1900, the *Brookings Press* reported that there were more than 50 businesses operating in Brookings.

Stereotypically the Midwest is known for a laid-back atmosphere. While the people of Brookings certainly know how to slow down and relax, it seems that the city is generally buzzing with excitement. With South Dakota State University (SDSU) comes year-round sporting events, special speakers, and theater and concert events, which the people of Brookings enjoy. The city is responsible for special events like the summer Arts Festival and the car show.

It would be impossible to talk about this unique city without incorporating the history and importance of SDSU. The college was started two years after the town was platted and grew along

with the city. Over the years, SDSU and the city of Brookings have depended on each other for continued growth and success. This book will highlight the long and prosperous connection that SDSU and Brookings have developed over time.

There were many great pictures to choose from while preparing this project. The archive department at SDSU's Briggs Library has an extensive collection of photographs of the city and the university. This book contains a variety of photographs that piece together the history of Brookings.

Every town has a story to tell, and if one listens closely to the people and buildings, the history can be retraced. This is the story of Brookings, South Dakota, and South Dakota State University.

One

PRAIRIE TOWN TO ENTERPRISING CITY

The heartbeat of any Midwest town can be found in its downtown area. Brookings's downtown was strategically placed near the railroad tracks during its early years for easy access to the trains. The city then expanded out from the downtown area toward the campus of South Dakota State College (SDSC). This area of Brookings still has many of the original houses and is a historic district.

Banks, general stores, lumberyards, drugstores, and land companies were some of the first businesses to take up residence on Main Avenue. Several professionals such as doctors, lawyers, and politicians also chose Main Avenue for their offices so they could be close to the action of the town. As Brookings continued to attract settlers, the buildings of Main Avenue grew and became permanent structures. Many of those original, early-1900s buildings still stand on Main Avenue. Over the years, several locally owned establishments have made their home in downtown Brookings.

While the downtown of Brookings has received several face-lifts over the years, it still serves as the proverbial heartbeat of the city. Restaurants, antique shops, clothing boutiques, and specialty stores grace an ever-changing and always busy downtown. Most of the businesses remain locally owned and operated, which adds to the welcoming atmosphere.

SDSU may be one of the largest employers in the city of Brookings, but there are also some local businesses that keep the city growing. Daktronics, started by former SDSU students, is known worldwide for its LCD (liquid crystal display) scoreboards. Another Brookings resident started Larson's Manufacturing, which makes storm doors that are sold nationwide. The Fishback family has expanded their banking business from Main Avenue to several surrounding cities. Brookings has blossomed from a mere village with a two-block Main Avenue into a rapidly expanding city.

Taken in the early 1880s, this photograph illustrates one of the first houses with a shingle roof in Brookings County. The house belonged to C. H. Stern and was located at the original Medary settlement. Stern's house also served as the first post office for the county. (Brookings County Museum.)

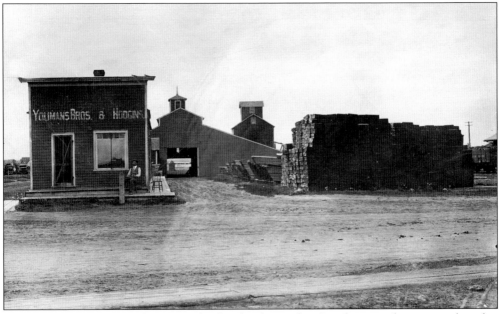

Youmans Brothers and Holgins was the first lumberyard in Brookings and is captured in this 1879 photograph. The lumberyard was located on prime real estate next to the railroad tracks for easy access. The business sold building materials and lumber at wholesale and retail, which proved essential for the growth of Brookings. (South Dakota State Agricultural Heritage Museum Photographic Collection.)

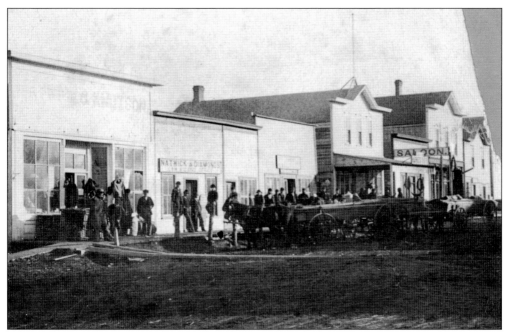

This early-1880s picture of Main Avenue depicts the first businesses in the town of Brookings. Some of the business names that can be read are "Natwick and Diamonds Land and Law Office" and "Saloon." Notice the dirt roads and wood-plank sidewalks. (South Dakota State Agricultural Heritage Museum Photographic Collection.)

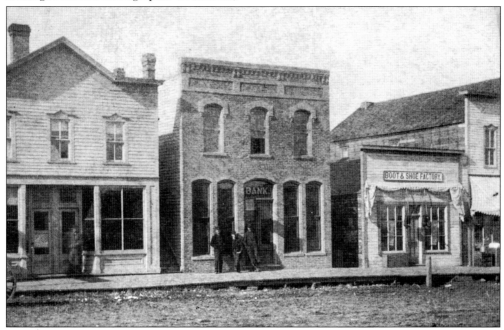

Taken the same day as the above photograph, this picture shows the other side of Brookings's developing Main Avenue. One of the town's first banks is already standing, as well as a boot and shoe shop. The building to the left of the bank may be the general store. (South Dakota State Agricultural Heritage Museum Photographic Collection.)

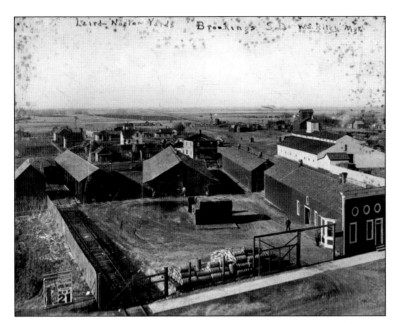

This early Brookings photograph states "Laird-Norton Yards, Brookings S.D." on the top. It also has the name W. S. Riley listed as the manager of the lumberyard. Several of Brookings's early homes can be seen in the background along with the grain elevator. Notice the railroad tracks on the left-hand side of the yard for easy access. (Rude's Furniture.)

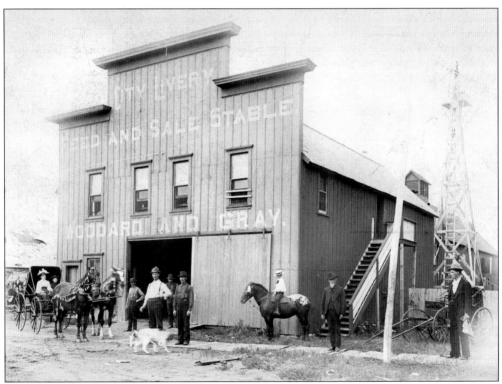

Stables were an important element in the early years of Brookings. The Woodard and Gray Livery, Feed, and Sale Stable was a thriving business on Main Avenue in Brookings. This building suffered the same fate as many other early Brookings businesses when it burned down in the early 1900s. Notice the ornamented horses hitched to the carriage in front. (South Dakota State Agricultural Heritage Museum Photographic Collection.)

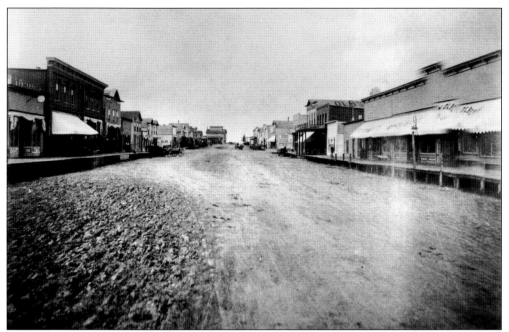

An early Main Avenue is depicted in this 1895 photograph of Brookings. The view is facing south and illustrates the raised wood-plank sidewalks that were indicative of a new town and helped to keep shoppers out of the mud and water. Several businesses had already found a home on Main Avenue. (Brookings County Museum.)

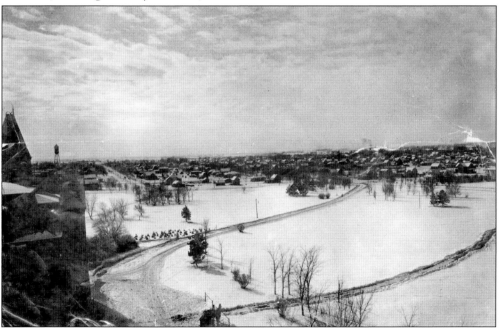

This aerial view of Brookings dates back to 1900 and was taken from the roof of Old Central on the SDSU campus. The view faces to the southeast and illustrates the size of Brookings at the beginning of the 20th century. The ground is covered in a blanket of snow, which is a common sight during South Dakota winters. (SDSU Archives.)

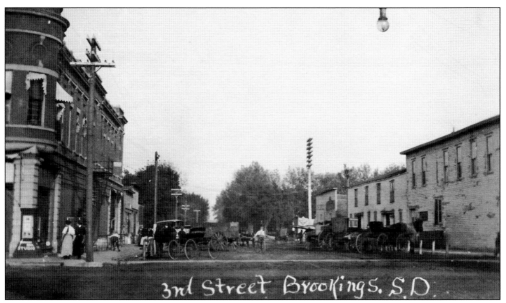

This early-1900s photograph depicts Fourth Street and faces east. The structure on the left-hand side is the Kendall Building. There are several wagons parked on the street as people shop in downtown Brookings. (Rude's Furniture.)

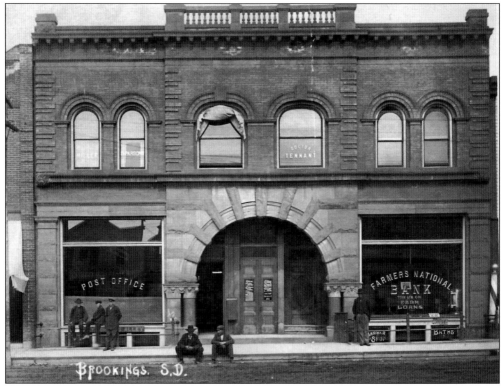

The Farmers National Bank and the Brookings Post Office were housed in this ornate building on Main Avenue. On the right side of the building, a barber pole is attached to the building, indicating that a bath and barbershop are housed in the basement. (Rude's Furniture.)

One of Brookings's oldest businesses is shown in this 1895 photograph of the First National Bank. This statuesque building was constructed in 1893 but later burned down. A replacement structure was built for $36,000, and later it became the residence of Northwestern National Bank. (Fishback Financial Corporation.)

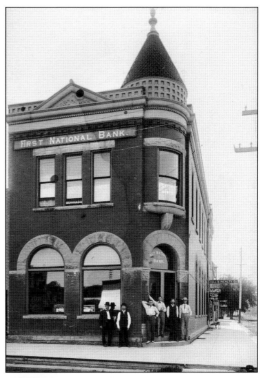

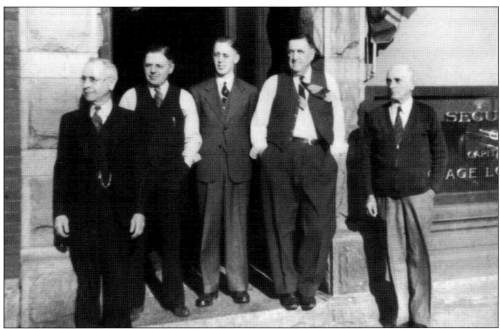

The employees of the Security National Bank pose in front of their building on Main Avenue in this photograph. The bank was opened by Horace Fishback Sr. in 1925 after taking a few years off from the banking business. The men in the picture are, from left to right, C. E. Kendall (insurance), Leon "Pete" Grape (teller), Lawrence Peterson (bookkeeper), John Murphy (teller), and Ed Carlisle (miscellaneous). (Fishback Financial Corporation.)

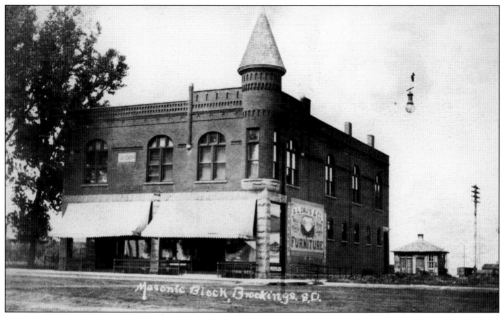

Built in 1894, the Masonic temple was a gathering place for community members and housed several businesses. The side of the building advertises the A. L. Davis and Company furniture store, which occupied the lower level of the building. Prominent architect Charles A. Dunham designed this building, which became a prominent fixture at the south end of Main Avenue. (South Dakota State Agricultural Heritage Museum Photographic Collection.)

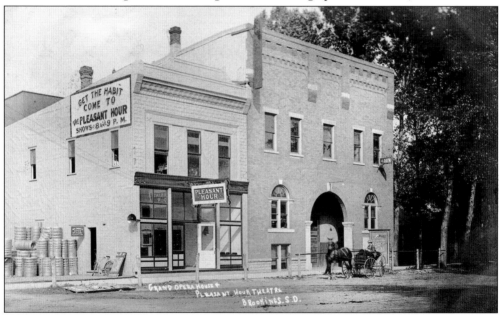

Providing entertainment for the people of Brookings, the Grand Opera House and Pleasant Hour Theatre are depicted in this 1909 photograph. The opera house was built in 1902 and has a unique arched doorway. Notice the sign hanging on the side of the Pleasant Hour, which states, "Implement Co. Office Upstairs." (South Dakota State Agricultural Heritage Museum Photographic Collection.)

Early Brookings merchants Charles A. Skinner, William Caldwell, Dr. A. W. Hyde, George Morehouse, John Wilson, F. J. Carlisle, H. H. Reeves, Thos. Ross, and C. E. Childs formed a syndicate in order to construct this building in 1901. This group of businessmen wanted to show the city's growth through this prominent building that housed a dry-goods store and offices. (South Dakota State Agricultural Heritage Museum Photographic Collection.)

This picture of Rude's Home Furniture dates back to 1910, when the store moved into the Kendall Building on Main Avenue. Rude's Furniture is one of the oldest family-owned businesses still operating in Brookings. From left to right, the men in the photograph are a Mr. Havervold, Orin Rude, George Rude (seated), and Bert Rude Sr. (Rude's Furniture.)

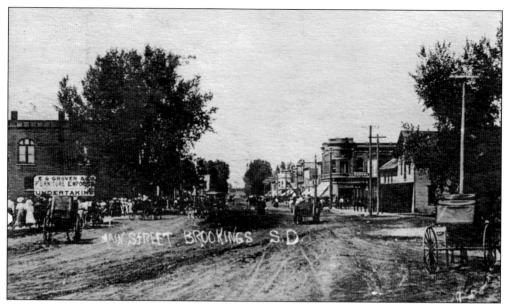

Main Avenue appears busy in this early-1900s postcard as people and wagons come and go from the train depot. A sign on the side of the Masonic temple advertises, "E. G. Grover Furniture Emporium." The Skinner Building can be seen on the right-hand side of the street. (Rude's Furniture.)

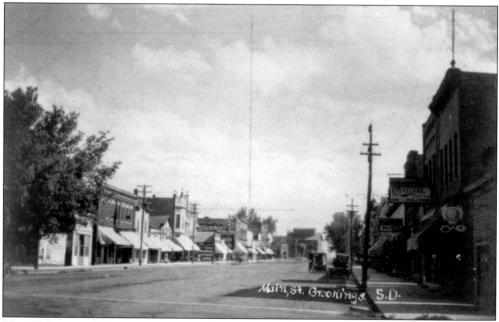

This 1912 postcard of Main Avenue shows the growth of downtown Brookings as several businesses now occupy space on the city's busiest street. The view is facing south, and the street appears to have been paved. Notice the awnings lining the west side of the street to keep out the afternoon sun. (South Dakota State Agricultural Heritage Museum Photographic Collection.)

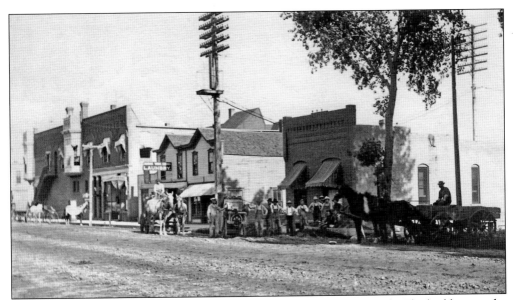

The north side of Fourth Street is depicted in this early-1900s photograph. The building on the far left of the picture is the Kendall Building on Main Avenue. A group of men take time out from street work to pose for the photograph. Men working on street improvements were a common sight in the early 1900s. (Rude's Furniture.)

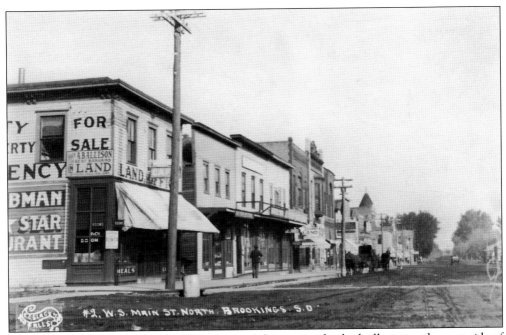

The year 1914 is clearly printed on the back of this postcard, which illustrates the west side of Main Avenue. One of the busiest businesses on Main, the Land Office is on the left-hand side of the street. The fifth and sixth buildings on the block are still standing on Main and are now Jim's Tap and George's Pizza. (Rude's Furniture.)

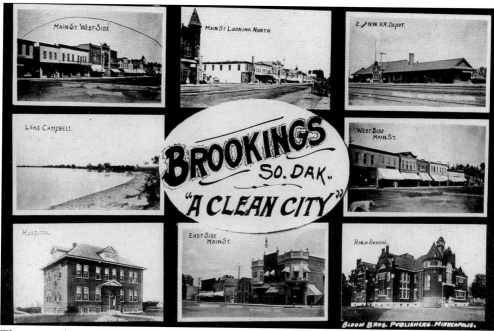

This particular postcard advertises Brookings as "A Clean City," which is meant to entice people to move to Brookings. In order to show the city's development, several views of Main Avenue, the new hospital, the high school, and the railroad depot are strategically placed, as well as a picture of nearby Lake Campbell. (SDSU Archives.)

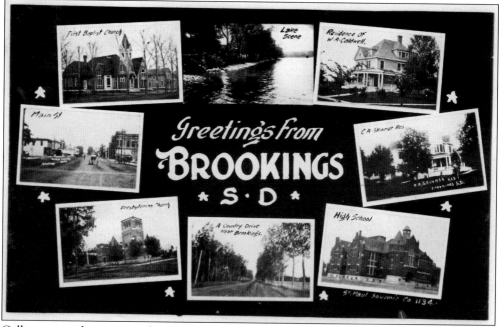

Collage postcards were a popular way of advertising for cities in the early 1900s throughout America. Much like the above postcard, this one is also meant to draw people to settle in Brookings. This postcard shows several of the city's established churches and some of the larger homes, which were important for relocating families. (Rude's Furniture.)

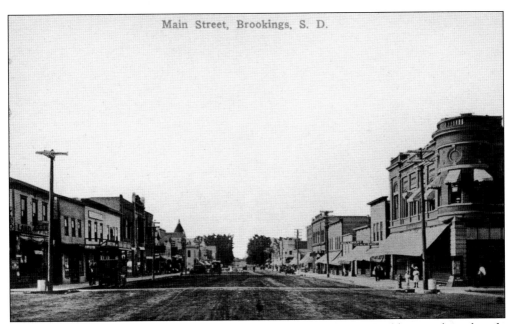

This picture of Main Avenue faces north and highlights the Skinner Building on the right side of the street. Notice that telephone polls and fire hydrants have already been installed. Fire hydrants were an important addition as many early businesses were lost to fire. Notice that the north end of Main Avenue is still somewhat undeveloped. (South Dakota State Agricultural Heritage Museum Photographic Collection.)

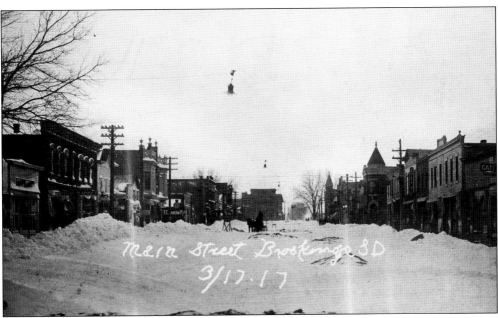

This picture of Main Avenue was taken in March 1917 after a blizzard came through Brookings. Snow is piled along the sides of the street, but the street was still difficult to navigate. A horse-drawn sled can be seen coming down the middle of the avenue. (South Dakota State Agricultural Heritage Museum Photographic Collection.)

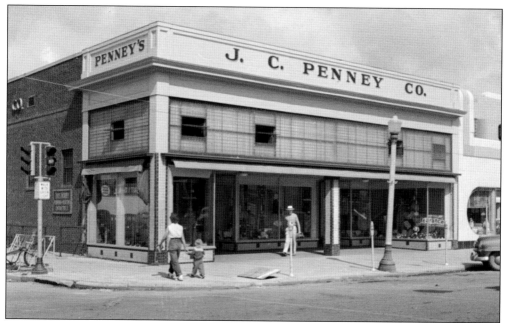

The J. C. Penney Company was a popular Main Avenue attraction because families could buy clothes for every generation in one place. The store had a unique front that made it stand out. Sioux River Bicycles has called this corner location home for the last several years. This late-1920s picture shows the traffic lights put in to control the flow of traffic. (SDSU Archives.)

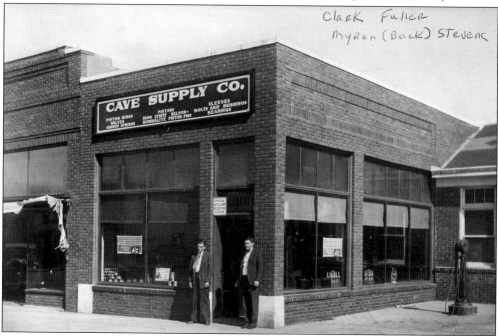

The Cave Supply Company was one of several automotive businesses to operate in downtown Brookings. The names Clark Fuller and Myron (Buck) Stevens are written in the upper corner of the picture. Currently there are three automotive shops operating in the downtown area of Brookings. (SDSU Archives.)

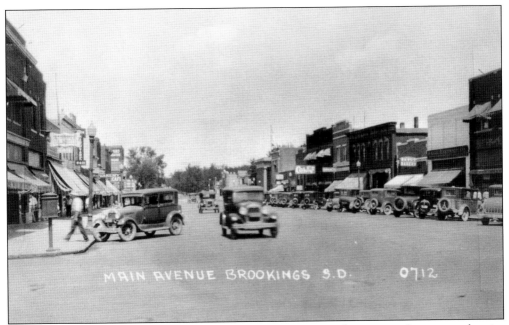

In this late-1940s north-facing picture of Main Avenue, many changes can be seen as the city continues to grow and prosper. Notice the variety of cars that line the street as people spend their day shopping or conducting business in downtown Brookings. (South Dakota State Agricultural Heritage Museum Photographic Collection.)

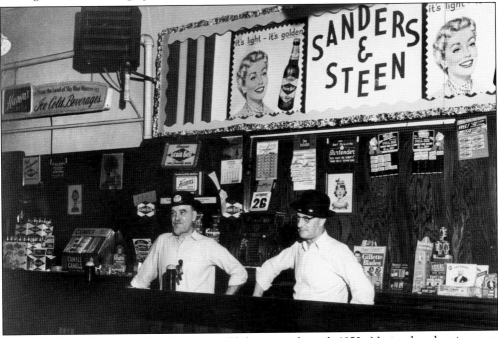

Sanders and Steen was a popular drinking establishment in the early 1950s. Notice the advertisements for Grain Belt and Hamm's. A sign hangs above the bartenders that states, "Don't stare at the Bartender, you may be goofy your self some day." Brookings now has several bars and restaurants where people gather in the downtown area. (SDSU Archives.)

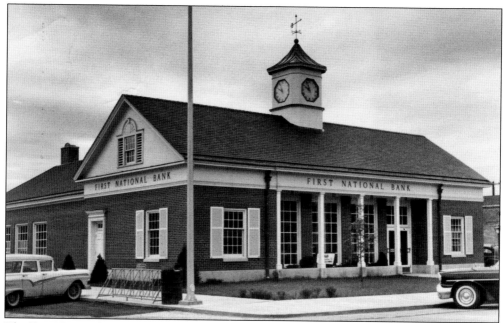

The First National Bank on the corner of Fifth Street was built in 1958 by Mills Construction. Horace Fishback Jr. worked closely with the architectural firm A. Moorman and Company out of Minneapolis in order to create the Colonial look that he wanted. This was the fourth bank to be built by the Fishback family in Brookings. (Fishback Financial Corporation.)

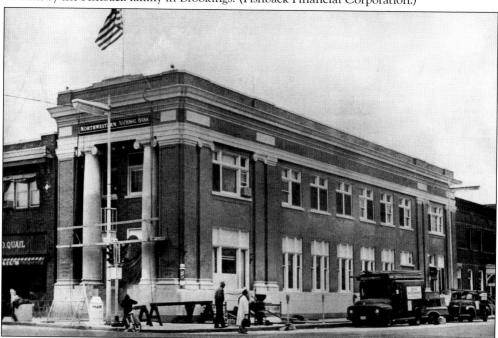

Replacing the First National Bank after it burned down, the Northwestern National Bank was a prominent building on Main Avenue and is seen getting a face-lift in this late-1950s photograph. Notice the barber's pole hanging on the right-hand corner, indicating a barbershop in the basement of the building, which is now O'Hares. (SDSU Archives.)

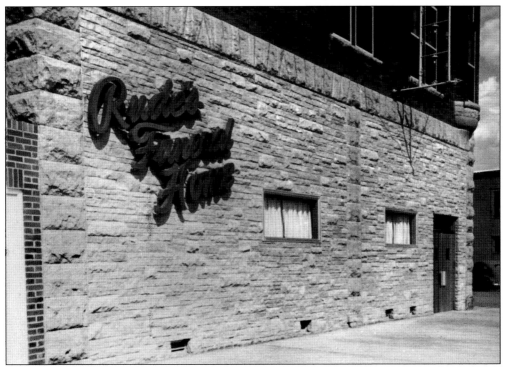

Rude's Funeral Home was started by George Rude in 1881 and still operates in Brookings today. This picture shows the front of the funeral home after it moved into the Masonic temple building on the south end of Main Avenue. The front was renovated with a brick wall replacing the windows that originally graced the front of the building. (Rude's Furniture.)

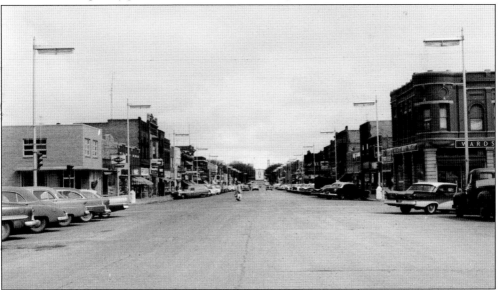

This is a north-facing view of Main Avenue from the 1950s. The First Lutheran Church can be seen at the far end of the street. Montgomery Ward's, which is at the far right side, is now the home of Skinner's Bar. This picture shows several now-classic cars parked on the street. (SDSU Archives.)

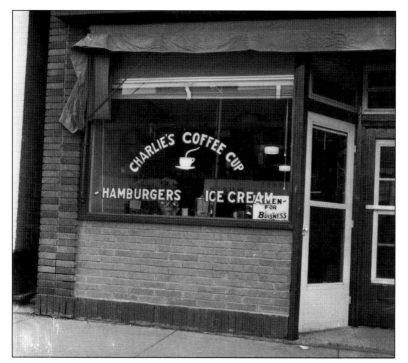

Charlie's Coffee Cup, a favorite Main Avenue hangout for many years, is pictured here in the 1950s. Hamburgers and ice cream are advertised on the window. What more could a person shopping in downtown Brookings ask for? (SDSU Archives.)

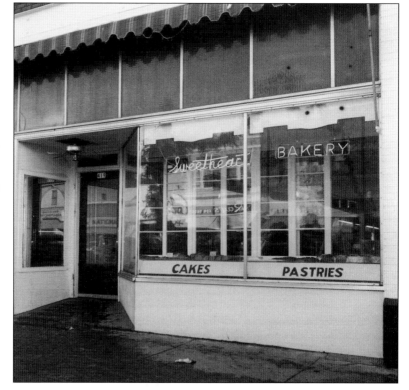

This early-1950s photograph shows the Sweetheart Bakery on Main Avenue. A variety of breads and cookies are neatly displayed in the front window to entice the people walking by. Note the reflection of Ray's Drug Store in the window, which was directly across the street. (SDSU Archives.)

The noontime rush required two waitresses to keep up with the stream of customers at the popular Shirley Drug Lunch counter that attracted all types of people, including policeman, housewives, and students, as this 1950s photograph illustrates. The shelves are lined with a variety of items, including cameras and film for sale. Several old Coca-Cola signs can be seen above the mirror. (SDSU Archives.)

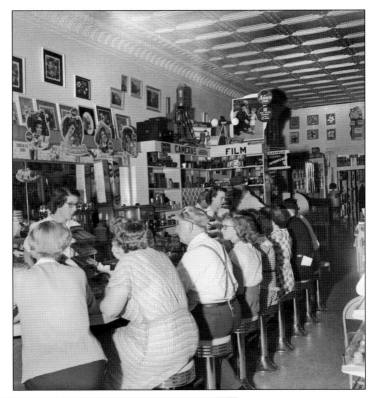

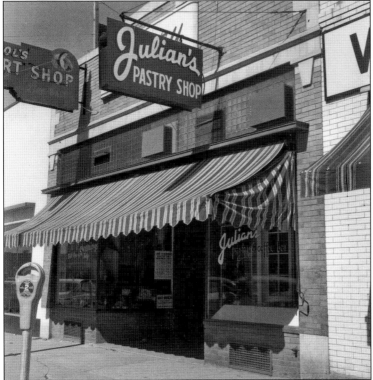

Julian's Pastry Shop and coffee bar is pictured in this late-1950s photograph. It was just one of many locally owned eating establishments in downtown Brookings. The sign to the left advertises a bait shop with "Live Bait." (SDSU Archives.)

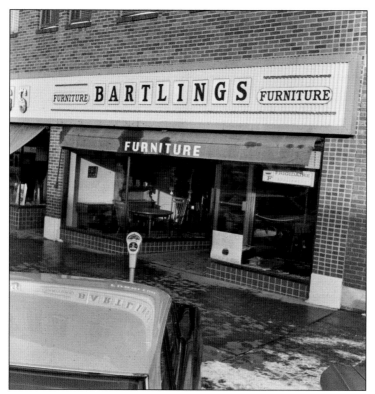

The Sellers and Bartling Building was constructed in 1926. Bartling's Furniture store was a family-run, Main Avenue establishment in downtown Brookings for many years and operated out of the bottom floor of the building. The top floor had offices that housed a doctor, a dentist, an attorney, and an insurance agency. A variety of establishments were also housed in the building's basement. (SDSU Archives.)

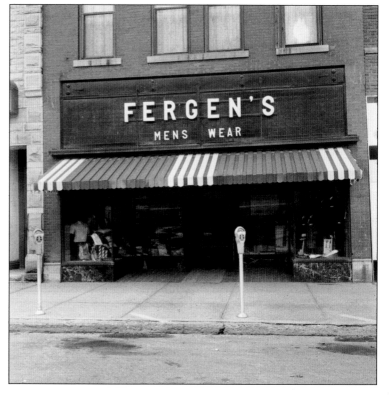

Fergen's Mens Wear, a popular destination for men of all ages, is shown in this 1950s photograph. Fergen's was started in the early 1950s by former SDSU basketball standout Jim Fergen. The business continues to thrive in the downtown Brookings area and is known for its quality clothing. (SDSU Archives.)

Stratton's Shoes on Main Avenue occupied what is now part of Rude's Furniture. This popular shoe store carried brands such as the Rand Shoe, the Trim Trod Shoe, and Poll Parrot Shoes in order to keep the people of Brookings in style. Notice the parking meters that once lined Main Avenue. (SDSU Archives.)

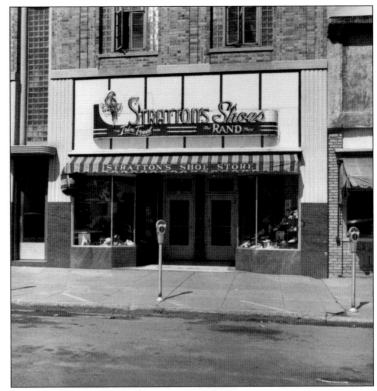

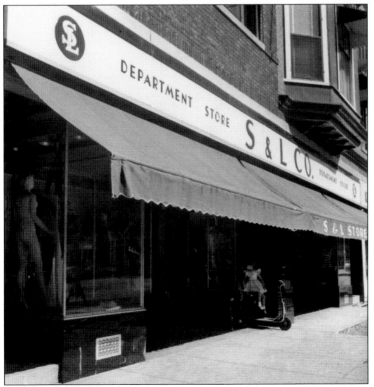

A popular shopping destination on Main Avenue, the S&L Company department store had a variety of items for the whole family. The S&L was next to Kendall's Drug in what is now the Sports Connection. The original S&L sign can still be seen under the Sports Connection's sign. (SDSU Archives.)

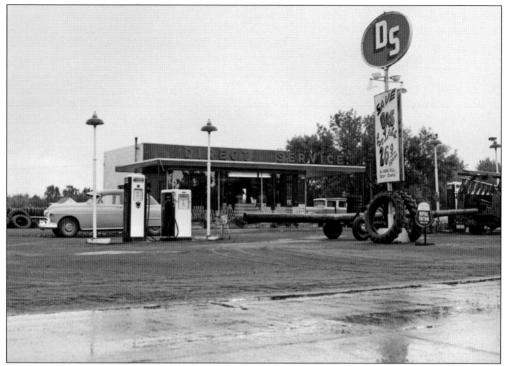

DS, or Direct Service Station, is pictured here in the early 1950s. It appears to be a small station with only four pumps. Notice the sign that advertises "Gas for Less" and that the store accepts "All Credit Cards." Credit cards became a popular form of payment beginning in the 1950s. (SDSU Archives.)

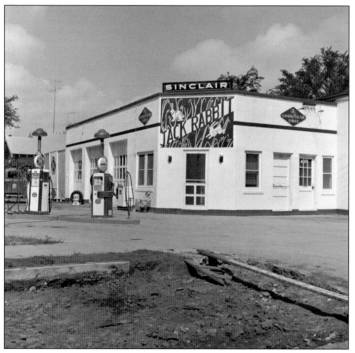

Adopting its name from the SDSU mascot, the jackrabbit, Jackrabbit Oil was strategically stationed on the corner of Medary Avenue and Eighth Street. It was across the street from the college campus, specifically Pugsley Union. Notice the old-style gas pumps sitting on the left side of the building. (SDSU Archives.)

Two

South Dakota State University

Affectionately coined the "College on the Hill," SDSU planted its feet on the north side of Brookings 129 years ago. As the Dakota Territory continued to grow, the territorial legislation began to authorize government-run establishments such as schools, colleges, and penitentiaries. John O'Brien Scobey, a businessman, lawyer, and newspaperman, traveled to the Dakota Territorial Legislature and secured the agricultural college for Brookings. The college was designated as a land-grant institution, which essentially meant that the school would be granted federally controlled land to develop or sell for funding. As part of the land-grant tradition, the college provided training in agriculture, science, and engineering. The college was also responsible for sponsoring experiment station research and several extension programs.

While the building of the college started slowly, by 1883 a distinct and statuesque structure could be seen on the northeast side of Brookings. The first semesters of South Dakota State College (SDSC) were quite different than what the school is now accustomed to. The first students that graced the campus never knew the burden of student-loan debts as tuition was free for residents of the territory. The day the doors officially opened, 50 students showed up for classes. Now more than 12,000 students register each year to attend SDSU. The board of regents originally established 10 chairs of instruction, all of which remain areas of study at the university today: agriculture, science, mathematics, English and English literature, modern languages, military tactics, veterinary science, practical business, political and domestic economy, and music.

Now, as a Division I university in athletics and the largest establishment of higher education in the state, the school attracts researchers, athletes, and students from around the world. SDSU proudly offers more than 200 undergraduate majors, 24 master's degrees, and 12 doctoral degrees. The annual Hobo Days activities attract thousands of people to the community each year, and the university athletic department has received some much-earned national attention lately. The women's basketball team made it to the NCAA National Women's Tournament in 2009. The volleyball team also made it to the NCAA National Tournament, and the football team recently made it to the NCAA playoffs. SDSU graduates have achieved some amazing accomplishments, including majority leader of the U.S. Senate, Congressional Medals of Honor, and a Nobel Prize in economics.

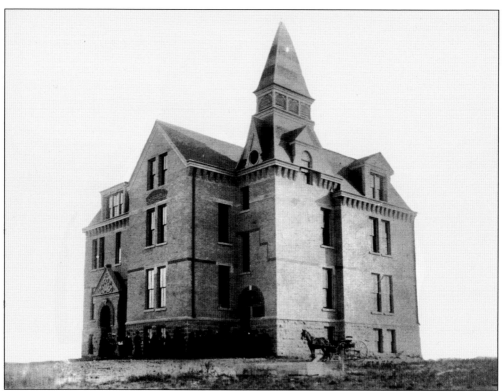

This 1880s image of Old Central is one of the first photographs of the original South Dakota State College campus. Constructed in 1883, Old Central was the first building on campus. As the first building, Old Central served as a dormitory, a dining room, a library, a museum, and even had classrooms and offices. (SDSU Archives.)

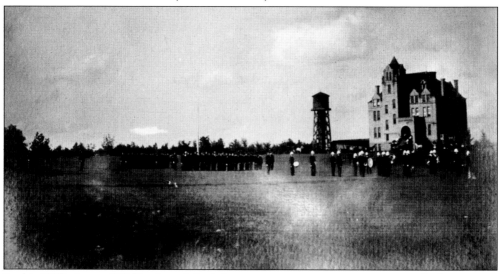

In this 1889 picture, Old North and the infamous campus water tower appear as the beginnings of South Dakota State College. A military group and band are practicing on the lawn as students watch from the steps of the building. Notice the pith helmets on the military band members. (SDSU Archives.)

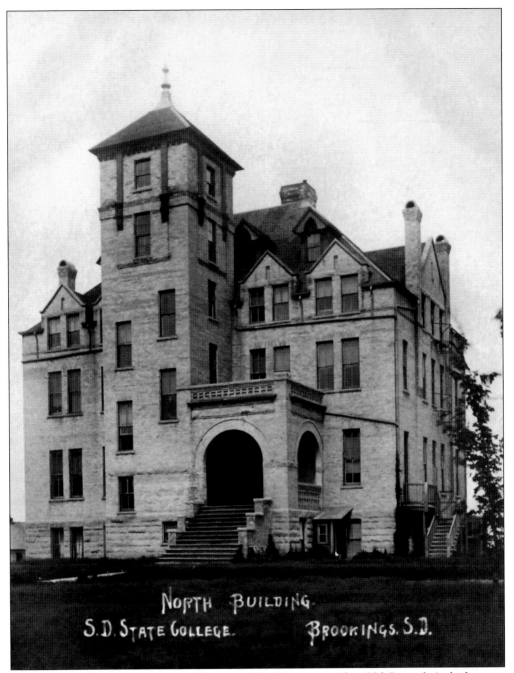

NORTH BUILDING.
S.D. STATE COLLEGE. BROOKINGS, S.D.

Old North, built in 1887, was originally supposed to be connected to Old Central. A clock tower, one of the building's distinguishing features, was added later when the classes of 1922 and 1923 donated. The original clock faces were saved and are now at home in the Tompkins Alumni Center courtyard. (Rude's Furniture.)

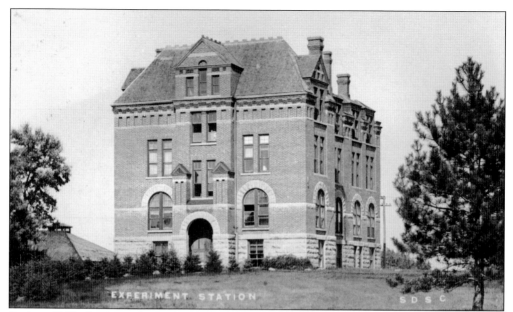

Built in 1885, the Agriculture Experiment Station, or the South Building as it was also known, had many functions. It housed the library, classrooms, and was also a girls' dormitory. The building was designed by Theodore Peterson and was the last remaining piece of the original campus until it was torn down in 1980. (SDSU Archives.)

This early-1900s photograph shows the Wildlife and Fisheries Building, which sat just west of Old North and Old Central on campus. The wildlife and fisheries department has expanded and is now housed in the Northern Plains Biostress Building. The department is involved with several research and environmental projects. (SDSU Archives.)

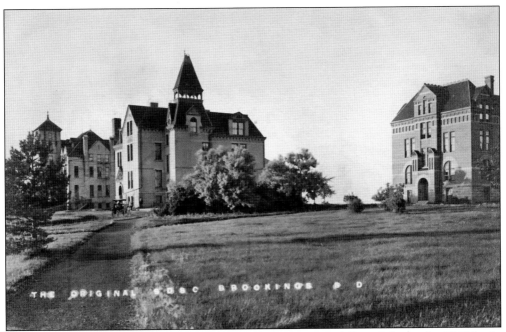

An interesting view of the campus is shown in this 1888 postcard. From left to right, Old North, Old Central, and the Agricultural Experiment Station are pictured. The road leading up to Old Central is visible, as well as a horse and buggy. The postcard reads, "The original SDSC Brookings, SD." (Rude's Furniture.)

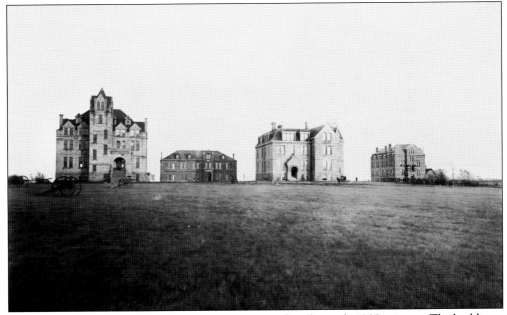

One of the first views of the SDSC campus is captured in this early-1900s picture. The buildings, from the left to right, are Old North, the Chemistry Building, Old Central, and the Agriculture Experiment Station. Notice the caissons on the left side of the green, the horse and buggy in front of Old Central, and the military group in front of the Agriculture Experiment Station. (SDSU Archives.)

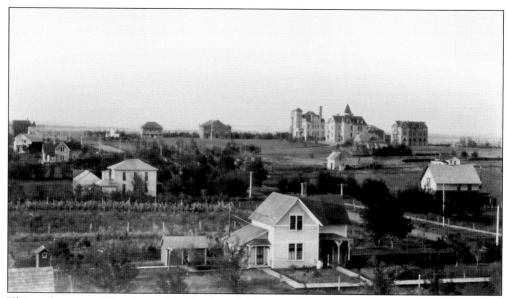

This early image of Brookings dates back to the late 1800s and shows some of the earliest homes in Brookings. The early structures of SDSC line the background and illustrate how it became known as "the College on the Hill" as they rise above the surrounding town. The buildings are, from right to left, the Agriculture Experiment Station, Old Central, Old North, the Gymnasium and Drill Hall, the Wildlife and Fisheries Building, and the Observatory. (SDSU Archives.)

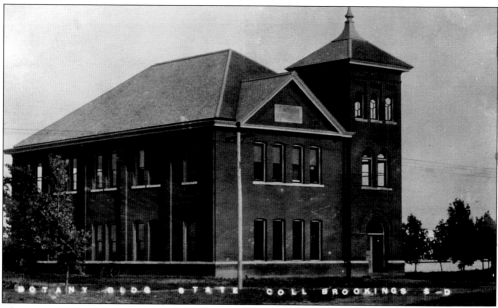

This 1910 postcard shows the Botany or Horticulture Building, which is one of the oldest facilities still in use on the SDSU campus. The wooden structure with a redbrick veneer was built in 1901. The old Botany Building currently sits behind the Administration Building on the SDSU campus. (SDSU Archives.)

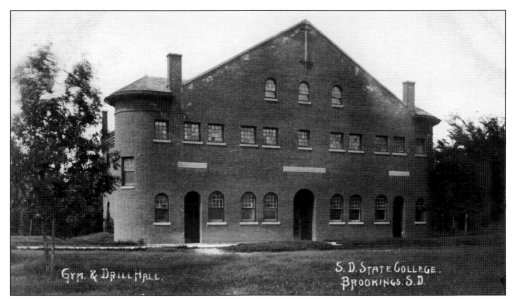

The SDSC Gymnasium and Drill Hall is shown in this early-1900s photograph. The building was constructed in 1899 so that the military program would have an area for indoor practice. Due to the college's success in military training, the state legislature set aside $80,000 in 1917 for the construction of a new armory/gymnasium. This allowed the ROTC program, which was started in 1916, to expand. (Rude's Furniture.)

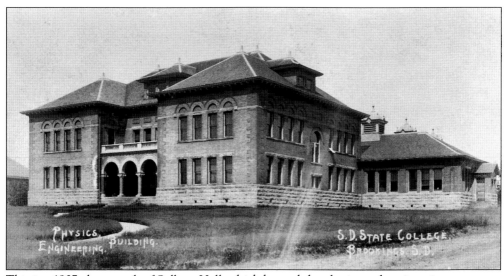

This is a 1907 photograph of Solberg Hall, which housed the physics and engineering programs. Constructed in 1901, the building was named after Halvor C. Solberg, an engineering professor who introduced mechanical engineering to SDSC. The focal point of this structure is its entrance, which features an arcaded, recessed gallery. (SDSU Archives.)

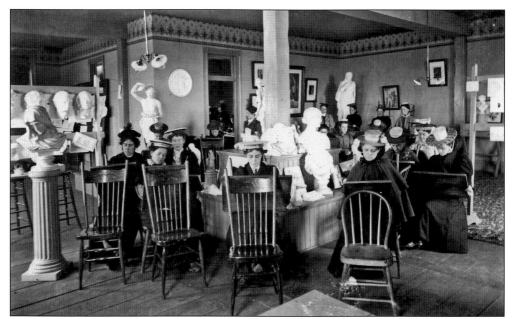

In this photograph from 1900, several women are captured as they draw in the art department at SDSC. There are several sculptures scattered throughout the classroom. The arts remain an important part of the university despite its previous reputation as an agricultural institution. Pay special attention to the women's dresses and hats, which illustrate the fashion of the early 1900s in the Midwest. (SDSU Archives.)

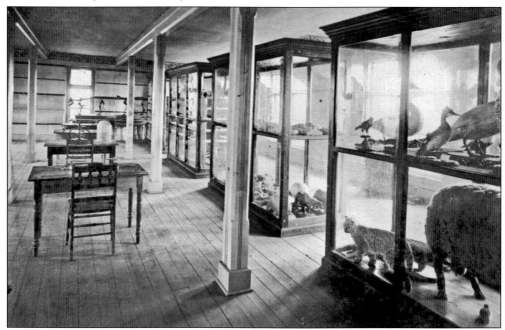

An early-1900s picture of the Zoological Lab on campus illustrates specimen cases that housed several different animals for the students to study. These specimens allowed students to understand tracking patterns and the body structures of diverse animals. Zoological studies are now part of the wildlife department. (SDSU Archives.)

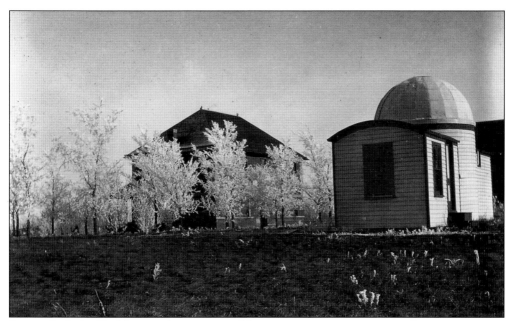

Due to the lack of buildings and open space of the prairie, stargazing was a popular pastime among students. An observatory was built on the South Dakota State College campus in November 1892. A handwritten notation on the back of the photograph states, "Creamery and Observatory." (SDSU Archives.)

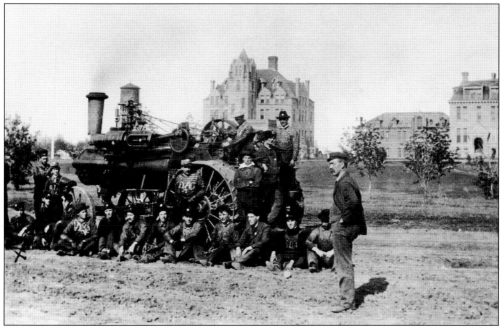

One of the college's steam engines and the steam engineering students are seen in this early-1900s picture. Since steam engines were the dominant source of power at the time, students found it important to study and understand how the engines worked. Notice that they are wearing similar outfits, which have SDAC (South Dakota Agricultural College, another name for the school during its early years) printed on them. (SDSU Archives.)

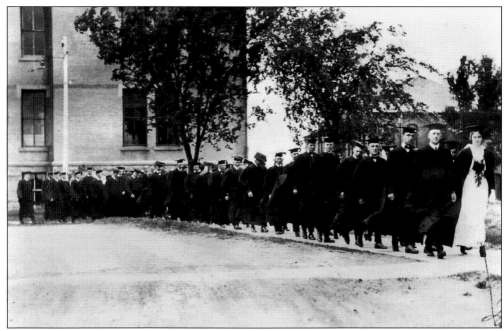

Members of the class of 1916 are captured walking to their graduation. Graduation ceremonies were held for several years at the Coolidge Sylvan Theatre on the green. Now SDSU graduation ceremonies are held twice a year in the campus arena and can last several hours with thousands of students graduating each year. (SDSU Archives.)

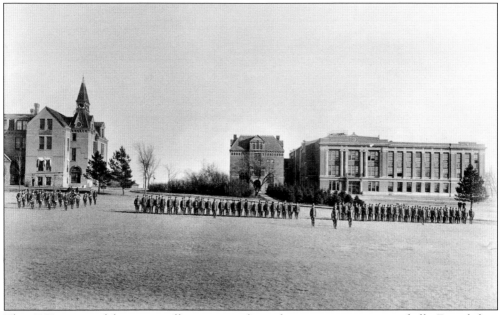

This 1917 picture of the campus illustrates a military formation practicing its drills. From left to right, Old Central, the Agriculture Experiment Station, and the first half of the Administration Building are in the background. The Agricultural Experiment Station was put on railroad tracks and moved in order for the north end of the Administration Building to be erected. (SDSU Archives.)

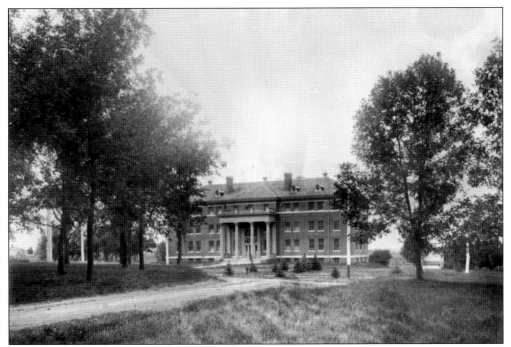

The newly built Wenona Hall is pictured from the east in this 1910 photograph. Notice the young evergreens lining the front lawn. The building was designed by an architect from Sioux Falls, Joseph J. Schwarz. The name "Wenona" comes from a Native American language and means the firstborn maiden in the family. (SDSU Archives.)

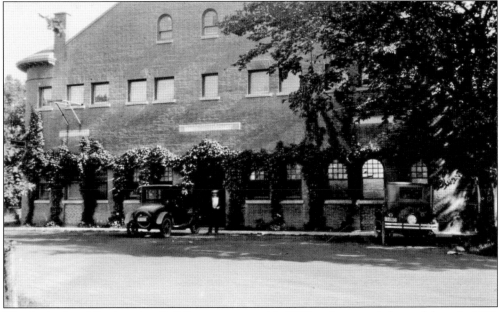

The Agricultural Engineering Building, constructed in 1899, unfortunately burned down in 1957. This view is from the south side of the building. Since the engineering department had become one of the largest departments on campus by the late 1950s, the state legislature quickly authorized a new structure to be built so classes could continue. (SDSU Archives.)

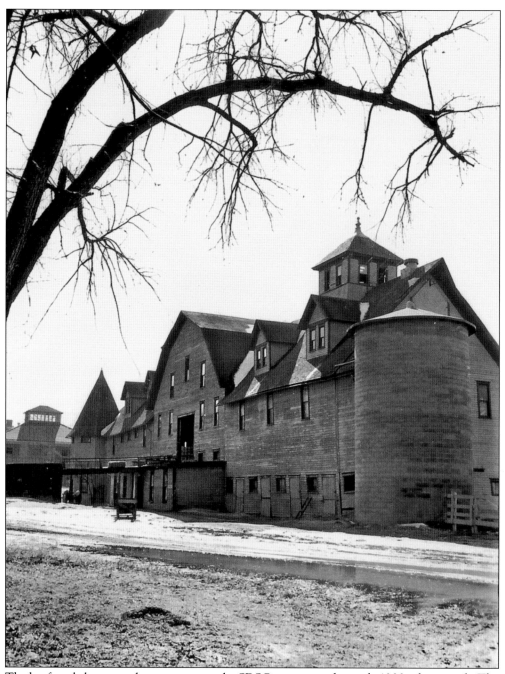

The beef cattle barn stands statuesque on the SDSC campus in this early-1900s photograph. The college was well known for having some of the most elaborate barns in the state. This particular barn had electricity, which was rare at that time for farm buildings but proved extremely useful for the workers. (SDSU Archives.)

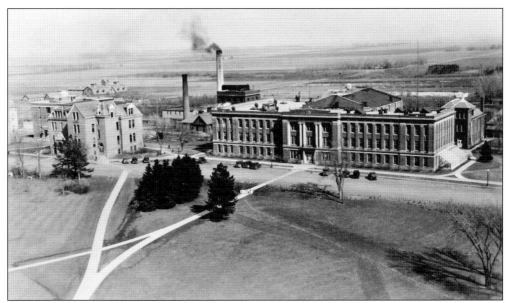

This elevated view of the campus shows the $100,000 Administration Building, which ended up being built in two phases. The middle and south end of the building were erected in 1912, while the north wing was added several years later in 1918. The building held classrooms, laboratories, offices, a greenhouse, and an auditorium. (SDSU Archives.)

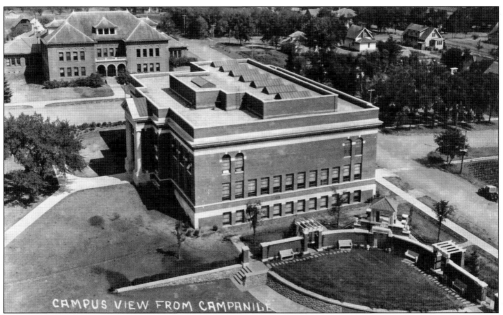

CAMPUS VIEW FROM CAMPANILE

This photograph, taken from the Campanile, shows the Coolidge Sylvan Theatre, the Lincoln Library, and Solberg Hall. Coolidge Sylvan Theatre was designed by two Sioux Falls architects named Perkins and McWayne, and it was dedicated by President Calvin Coolidge and his wife, Grace, in 1927. The outside theater played host to concerts, college events, and even graduations. (Rude's Furniture.)

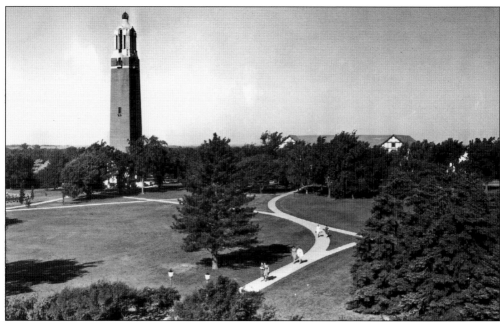

This north-facing view shows the campus green and the Campanile. The 165-foot-tall structure was gifted to the college by former engineering graduate Charles Coughlin, and the cornerstone was laid during commencement ceremonies in June 1929. The Campanile remains the tallest building in Brookings and is the tallest chime tower in the state of South Dakota. (SDSU Archives.)

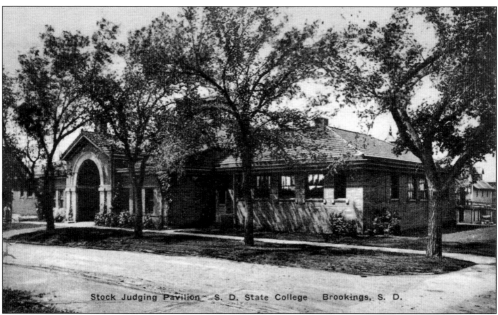

Stock Judging Pavilion — S. D. State College Brookings, S. D.

This 1939 postcard captures the Stock Judging Pavilion with the cattle barn behind it. In 1917, the state legislature set aside $20,000 to build the Stock Judging Pavilion. The yearly gathering of agriculture students, known as Little International, was started on the SDSC campus in 1921 and drew large crowds to the Stock Judging Pavilion for a livestock and grain exposition. (Rude's Furniture.)

As enrollment continued to expand, the college filled a large void with the building of a student union. The new building was named after former SDSC president Charles Pugsley, who helped steer the college through many rough years. This 1940s view of Pugsley Student Union is facing southwest. (SDSU Archives.)

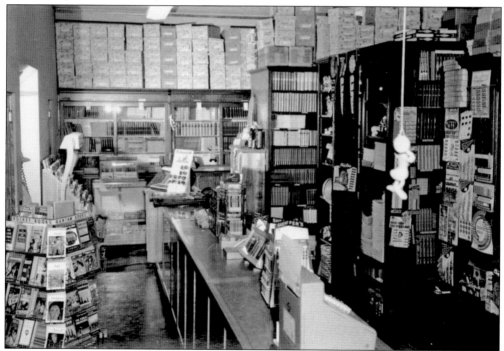

An interior view of the campus bookstore is pictured here, stuffed to the brim with textbooks and materials. The bookstore was in Pugsley Student Union until 1973, when the new student union was built on the east side of the campus. The bookstore has undergone several changes over the years and is still one of the busiest places on campus during the first week of each semester. (SDSU Archives.)

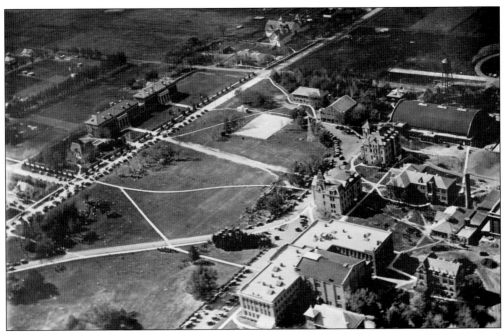

This 1920s aerial view of the campus highlights the college's growth during its first 50 years. While Old North and Old Central are still standing, there are several new additions, such as Wenona Hall (right) and Wecota Hall on the left side of the photograph. Notice the people gathering on the green and the cars lining the streets. (SDSU Archives.)

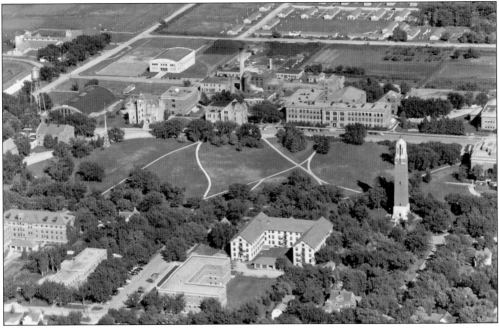

This is an early-1950s aerial view of the campus from the west. There are several new additions to the campus, including the Campanile, Scobey Hall, and several agriculture buildings behind the Administration Building. Scobey Hall was named after John Scobey, who brought the college to Brookings. (SDSU Archives.)

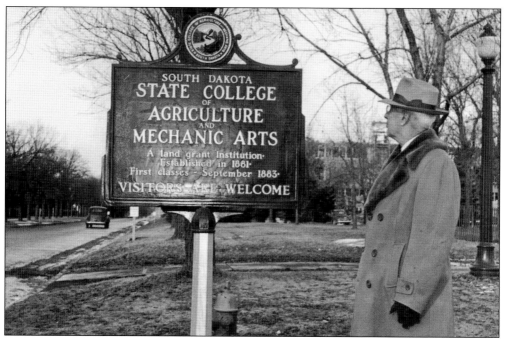

The South Dakota State College sign welcoming visitors and students to campus stood outside of Coolidge Sylvan Theatre green next to the Campanile for several years until the school's name change. (SDSU Archives.)

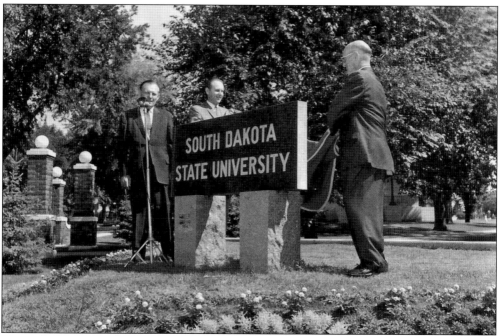

The college's name changed in 1963 to South Dakota State University. It was a momentous occasion, and this picture shows the sign being unveiled as it takes its place by the Campanile and Coolidge Sylvan Theatre. The men in this picture are, from left to right, H. M. Briggs, Tom Mills, and David Doner. (SDSU Archives.)

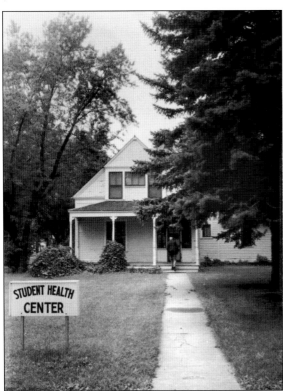

This 1950s photograph shows the Student Health Center for the campus. As funding seemed hard to come by for many years, the campus used whatever resources were available. Several houses close to campus were used for offices and other facilities, as they were cheaper to renovate for the school's needs. (SDSU Archives.)

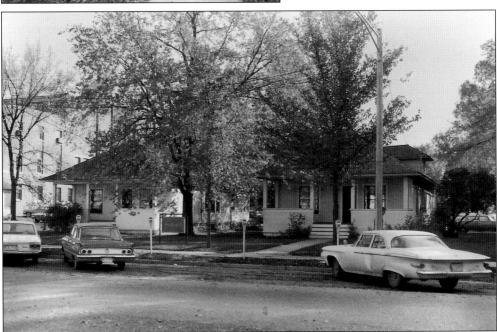

In this 1950s photograph, two of the houses that were used for some of the smaller departments on campus are pictured. The sign posted outside reads, "English Offices." These two houses sit behind Pugsley Student Union and were later torn down. The English department has since found a home in the basement of Scobey Hall. (SDSU Archives.)

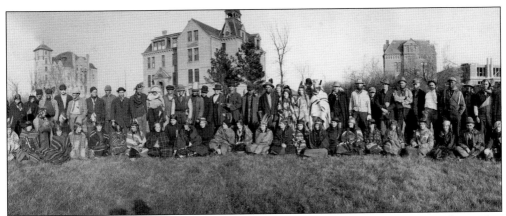

Hobo Days, which started in 1912, quickly became an important tradition for SDSC students. This postcard shows several students dressed as hobos, pioneers, and even Native Americans in order to celebrate homecoming. The homecoming tradition is largely credited to SDSC alumnus R. Adams Dutcher, who got the idea after visiting the University of Missouri. (SDSU Archives.)

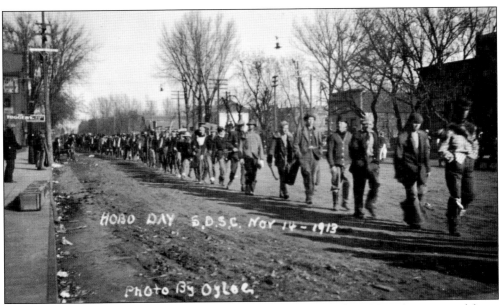

This 1913 picture of downtown Brookings shows "hobos" walking along Main Avenue to celebrate Hobo Days. One of the first events of Hobo Days was a nightshirt parade, which eventually turned into a daytime parade of hobos and Native American maidens. Since most students were low on funds, they found that dressing like a hobo was both cheap and entertaining. (SDSU Archives.)

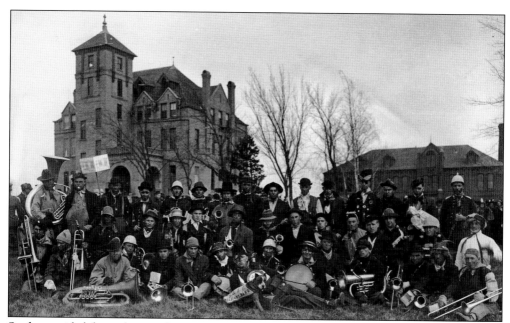

Students prided themselves on their unique costumes for Hobo Days. In the early years of the event, every student participated in the parades marching down Main Avenue. This 1914 photograph shows the SDSC Military Band in costume and ready for its performance in the parade. Old North and the Chemistry Building are in the background. (SDSU Archives.)

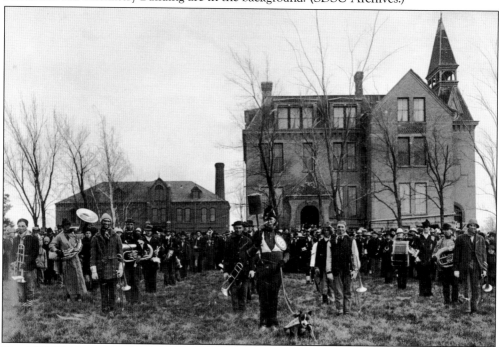

The SDSC Military Band is lined up and ready to perform in the Hobo Days parade. Notice the conductor and his dog ready to lead the pack. The Chemistry Building and Old Central are in the background. The parade made its way to the train depot so it could meet the opposing football team, which would be arriving for the big homecoming game. (SDSU Archives.)

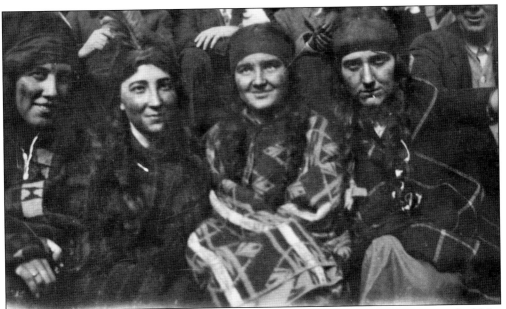

In this 1914 photograph, several young women are seen dressed as Native Americans for Hobo Days. Students who were new to the area were intrigued by Native Americans and the way they dressed. Many students used Hobo Days as a time to emulate this unique dress through their costumes. (SDSU Archives.)

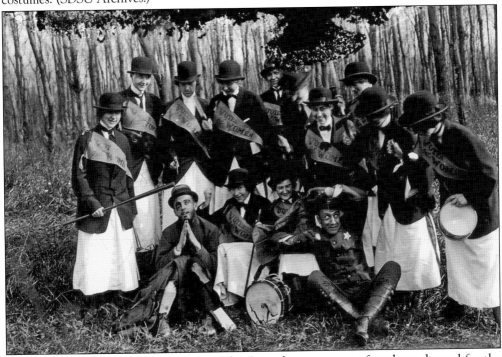

This undated photograph of an early Hobo Days shows a group of students dressed for the parade. Many students were able to use Hobo Days as a way to express their views and beliefs on current issues. The students in this group are wearing banners that read, "Votes for Women." (SDSU Archives.)

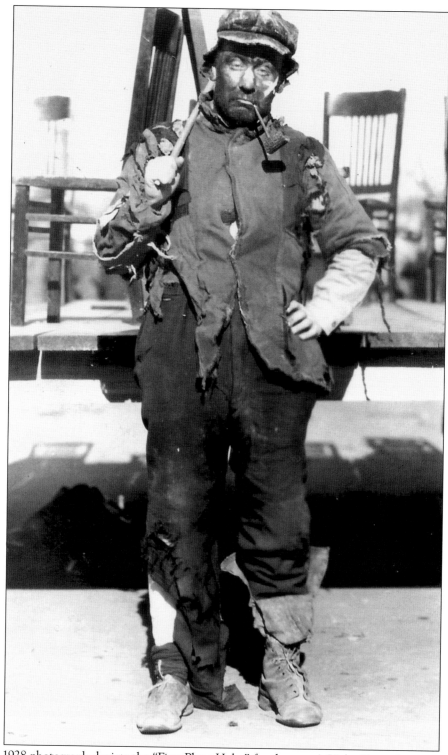

This 1928 photograph depicts the "First Place Hobo" for that year's Hobo Days. A notation on the back of the photograph states, "I have him in class this term." (SDSU Archives.)

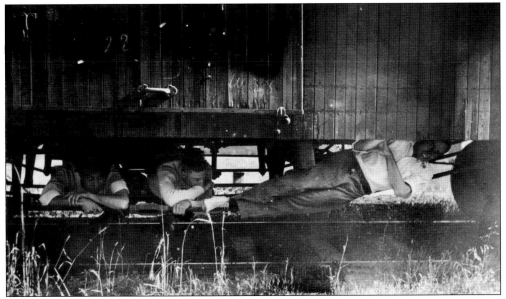

Three SDSC students illustrate a literal take on becoming hobos in this early-1900s postcard. Riding the rails across the Midwest was a fantasy for many young people in the early 1900s, as they wanted to explore the country. Many authors incorporated this theme in their novels, which romanticized the idea further. (SDSU Archives.)

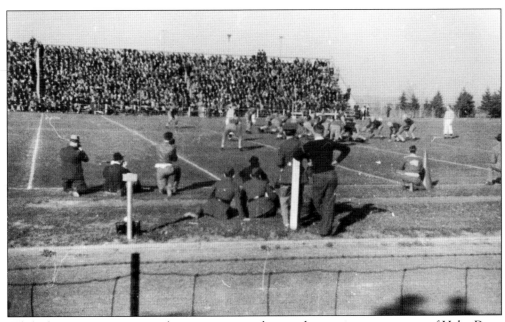

While dressing in costume and participating in the parade were important parts of Hobo Days, nothing took priority quite like the homecoming football game. This 1939 photograph shows the packed stands as students and townspeople cheer on the SDSC football team. The SDSU football team continues to thrive and draws record-setting crowds each season. (SDSU Archives.)

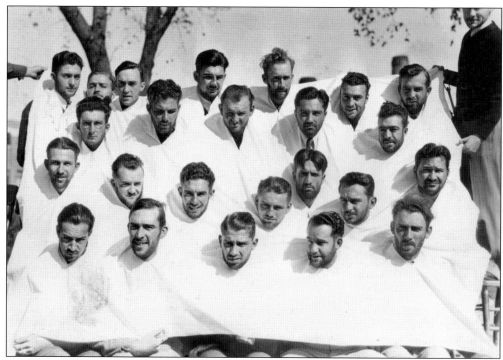

Participating in the beard contest quickly became a tradition for the SDSC male students. The contest usually lasted for the month prior to Hobo Days and culminated with the men getting their beards shaved off during Hobo Days. In this 1932 photograph, several men show off their progress before getting shaved. (SDSU Archives.)

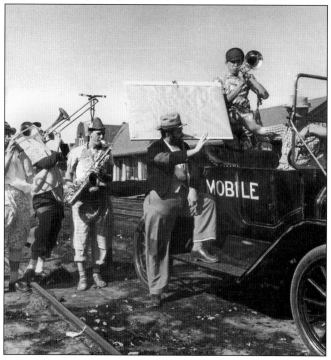

The infamous "bummobile" is pictured here carrying hobos. The bummobile has been part of the Hobo Days parade for more than 100 years. One of the original bummobiles was recently restored and made its first public appearance in the 2009 Hobo Days parade. (SDSU Archives.)

Three

SERVING THE PUBLIC

Every community relies on its public servants to keep the city functioning and protected. Many of these individuals, such as mailmen, police officers, and firemen, receive little recognition but continue to show up every day out of a sense of duty to their community. As many communities send their loved ones off to war, the respect and honor shown to servicemen, servicewomen, and public servants now holds even greater significance.

The formation of Brookings relied heavily on the support of public servants—men who gave their time, money, and ideas in order to develop a mere village into the thriving community it is now. Men such as Horace Fishback Sr., George Morehouse, George Sexauer, Charles and William Skinner, William Caldwell, and Bert Rude required little recognition for their generous contributions to Brookings. Several businessmen still give of their spare time to serve on committees and boards that aim at improving the city, such as the Boys and Girls Club, the United Way, and the Enterprise Institute.

The fire department remains a volunteer organization and always has plenty of willing men and women. The Brookings Police Department has grown with the city in order to protect and serve the citizens.

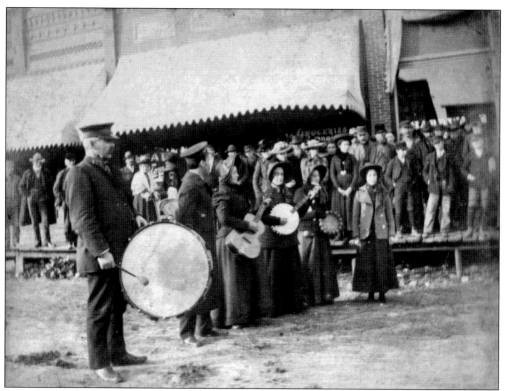

This photograph, dating back to the late 1880s, shows a Salvation Army Band performing on Main Avenue. Salvation Army officers came to the United States in early 1880. They used bands to proclaim the Gospel of Jesus Christ through music. This picture illustrates the raised plank sidewalks that lined Main Avenue until the early 1900s. (Brookings County Museum.)

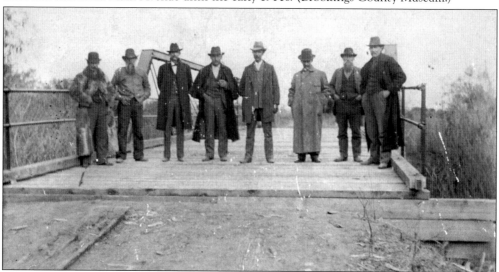

In this 1898 picture, the Brookings County commissioners are captured as they inspect a steel span and approach for safety. Having well-built bridges and roads were essential for the growth of Brookings, and the early county commissioners took their job seriously as they checked every bridge throughout the county. (Rude's Furniture.)

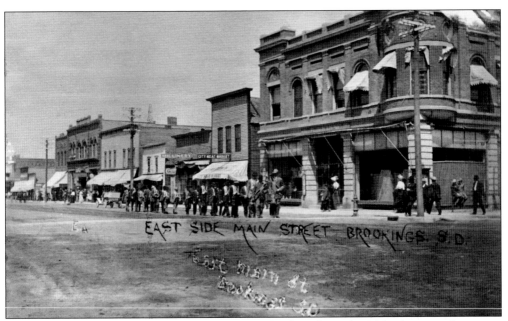

This picture of the east side of Main Avenue dates back to the early 1900s. A group of men can be seen marching in the middle of the street and wearing banners. Veterans and city officials were often seen walking down Main Avenue. The building on the corner is the Skinner Building. (Rude's Furniture.)

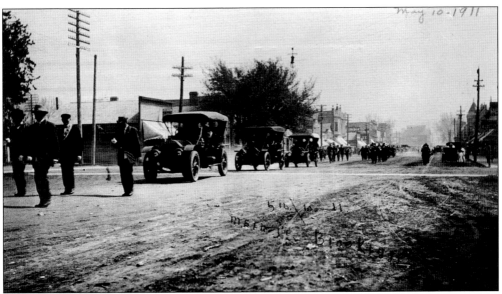

Groups of veterans marching down Main Avenue were a common sight in the early 1900s. Community members would gather to show their appreciation for the men's service. Written on this photograph is the date, May 10, 1911. This view shows that streetlights and telephone polls have been added to Main Avenue. (SDSU Archives.)

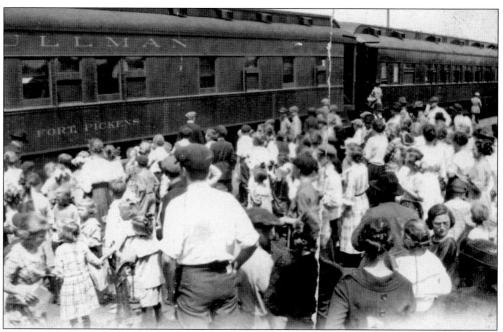

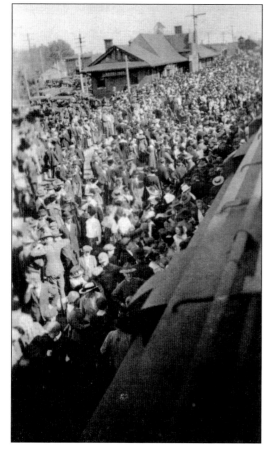

The back of this photograph reads, "Troops leaving for War, 1918." Family members and friends found it important to show their support by coming to the train station to welcome or send off troops. This remains an important tradition for the family members of servicemen and servicewoman. (SDSU Archives.)

This photograph of the crowded Brookings train depot has become legendary for its striking visual affect. Handwritten on the back of the original picture is the caption "WWI Troops leaving." Notice that men in uniforms are scattered throughout the crowd as they say good-bye to their loved ones. (Brookings County Museum.)

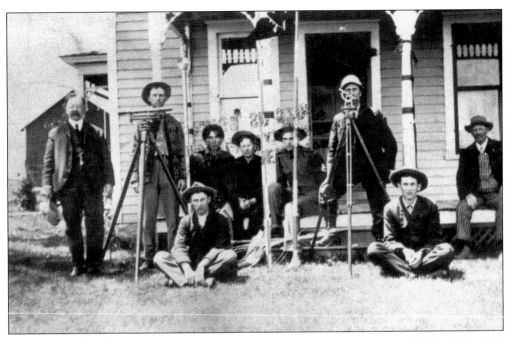

A surveying class from South Dakota State College is pictured in this 1906 postcard. This group of men helped to survey the railroad from Brookings to Sioux Falls. Over the years, engineering students have learned to survey throughout the campus and the city. These students learned by surveying for the railroad company. (SDSU Archives.)

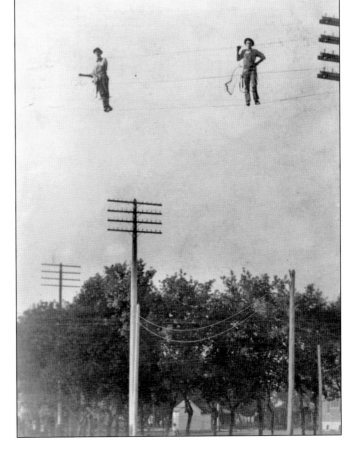

In this early-1900s photograph, two men are modernizing Brookings's communication systems by installing telephone wires. Safety gear was obviously not a job requirement in those days. (SDSU Archives.)

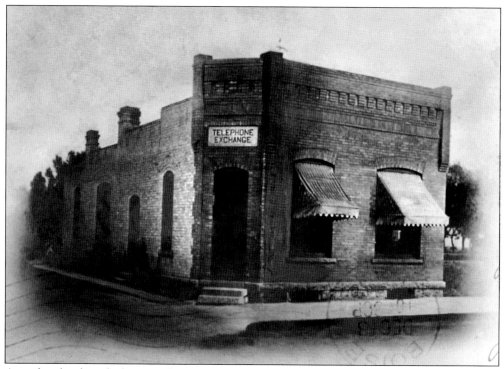

A worker for the telephone exchange sent this postcard to a relative in 1908 to let her family know that she enjoyed her job. The telephone company was started in 1899, and this building was constructed in 1902. The financing for the telephone company came from the sale of stock. (Rude's Furniture.)

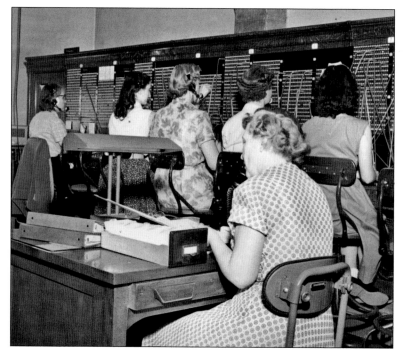

By 1915, women had replaced men as the switchboard operators across the country. This 1950s photograph shows several women hard at work connecting telephone calls for the people of Brookings. (SDSU Archives.)

This 1903 photograph shows the construction of the Brookings Light Plant. Two construction workers can be seen standing on the roof installing the cupolas. The money for the project came from a stock company. E. E. Gaylord was largely responsible for bringing electricity to Brookings and was the first manager of the electric light plant. (SDSU Archives.)

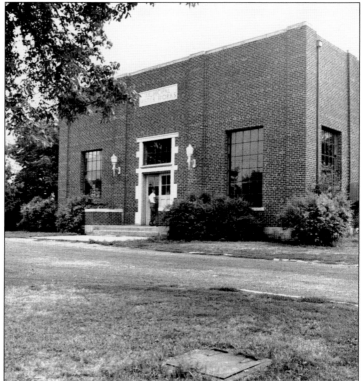

The Brookings Municipal Water Works, located on North Highway 77, is pictured here in the 1930s. Having working water systems is an essential part of any community, and the City of Brookings has a crew devoted to providing great service to the people of Brookings. (SDSU Archives.)

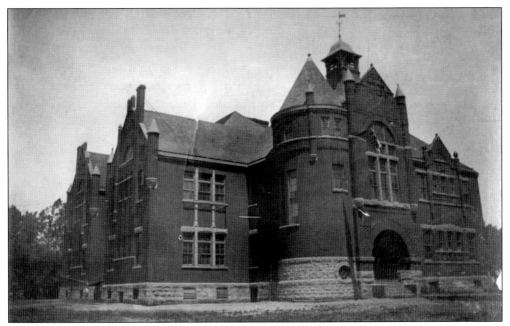

Known throughout Brookings as the "Red Castle," this picture illustrates the imposing three-story brick school. The school was built in 1888 for $10,000 and was designed by architect Charles A. Dunham. Dunham also designed the Masonic temple in Brookings, and the two structures share some striking similarities. In 1935, the Red Castle was torn down to make room for a new, $90,000 school. (Brookings County Museum.)

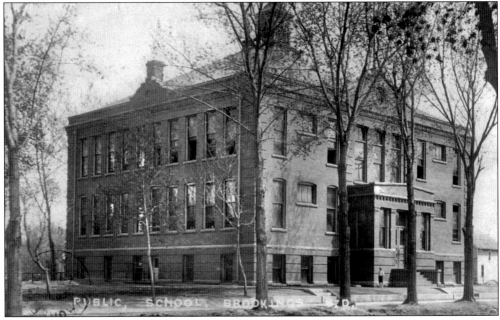

The caption on this 1908 postcard reads, "Public School, Brookings, S.D." This school was also referred to as the "auxiliary school" and was constructed in 1908 in order to accommodate the growing number of children in Brookings. The building was torn down sometime in the 1940s after a new grade school was built. (Rude's Furniture.)

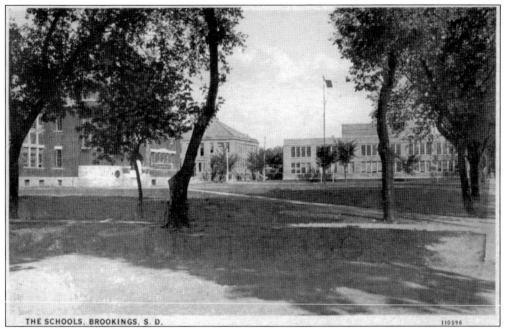

THE SCHOOLS, BROOKINGS, S. D. 110596

This postcard shows "the Schools" for Brookings. From left to right, the buildings are the Red Castle, the auxiliary school, and the high school. The high school was built in 1921 for $165,000. These three buildings comprised the Brookings schools until 1935. This postcard was used as advertising to illustrate the city's growth. (Rude's Furniture.)

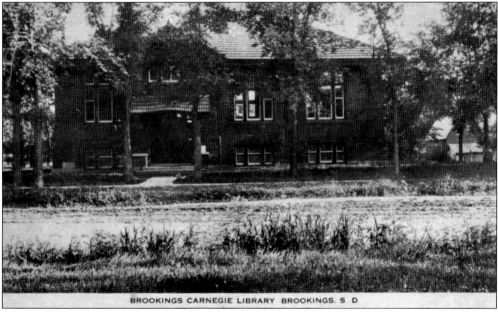

BROOKINGS CARNEGIE LIBRARY BROOKINGS. S D

The Carnegie Library, which was designed by renowned library architect G. C. Miller from Chicago, is pictured in this 1916 postcard. Miller took great pride in his unique design. The library was 1 of 25 libraries in South Dakota to be funded by Andrew Carnegie. This served as the public library for Brookings until 1976. (Rude's Furniture.)

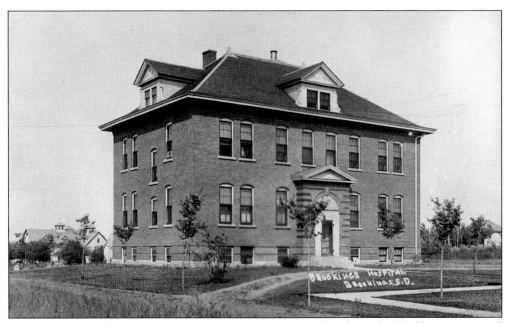

One of Brookings's hospitals is captured in this 1912 photograph. The 21-bed building was erected in 1907 by contractor Hans Jerde and served as the community's hospital until the 1930s. The funding for the project came from the Brookings Hospital Company, which was incorporated by Brookings businessmen George Sexauer and Horace Fishback Sr., along with Drs. F. E. Boyden and B. T. Green. (South Dakota State Agricultural Heritage Museum Photographic Collection.)

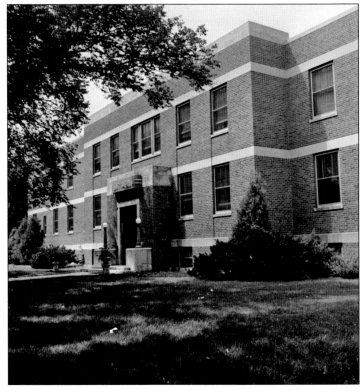

This is an early-1950s photograph of the Brookings Hospital. Brookings has had several hospitals over the years, but the city has always prided itself on patient care. The city health system has formed an invaluable relationship with SDSU, which ensures that students can study under health care professionals throughout the community and that health care professionals can continue their learning through a variety of programs offered on campus. (SDSU Archives.)

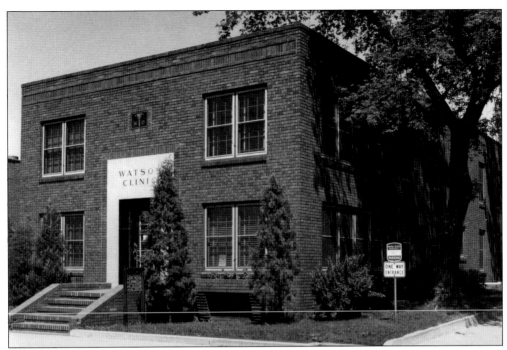

The Watson Clinic was built in 1939 on Main Avenue by Dr. E. Sheldon Watson. This 1954 photograph shows that Dr. Watson was still operating his own clinic even though the Brookings Clinic was growing in size. (SDSU Archives.)

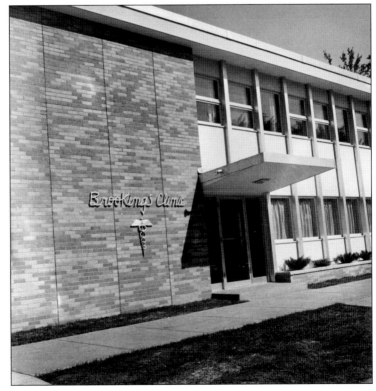

In this late-1950s photograph, the Brookings Clinic is depicted. This building is just blocks from where the Watson Clinic sat in downtown Brookings. It is now home to apartments and several businesses. The Brookings Clinic is now owned by the Avera Health System and resides on the east side of town next to the hospital. (SDSU Archives.)

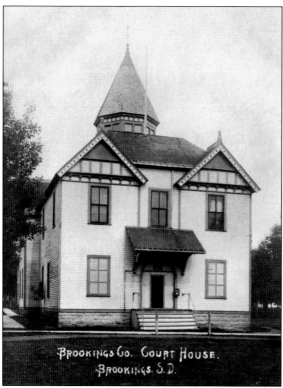

The first courthouse for Brookings County looked more like a house than a government building, as can be seen in this early-1900s photograph. Built in 1883, this structure served as the county courthouse until 1910, when it was razed. The building cost $7,000 to construct, and $4,000 of that came directly from the City of Brookings. (Rude's Furniture.)

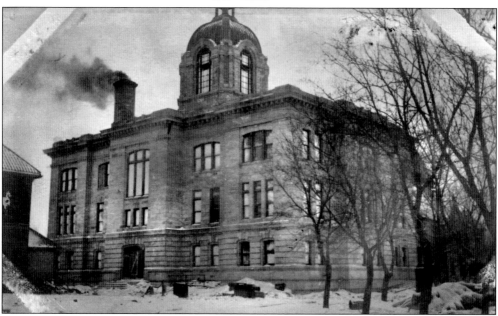

Brookings County's current courthouse was designed by architects Bell, Tyrie, and Chapman and was constructed by the J. B. Nelsen Construction Company in 1912. According to the National Register of Historic Places, this building represents the popular Renaissance Revival style popular in the early 1900s. While there have been some additions to this building, it still serves as the courthouse for Brookings County. (Rude's Furniture.)

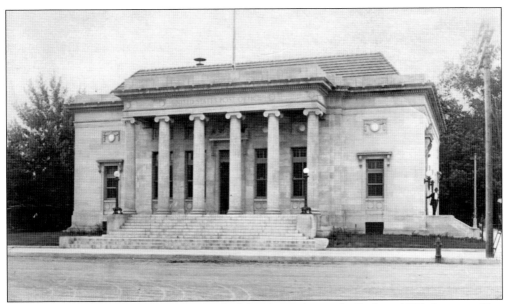

This impressive corner structure is typical of the Beaux-Arts style. Built in 1915, the post office was constructed of Bedford limestone and cost $75,000. This 1920s postcard illustrates the building's sheer mass and highlights its Ionic-columned portico entrance. Requiring only a few modifications over the years, the post office still holds its place on the corner of Main Avenue and Fifth Street. (Rude's Furniture.)

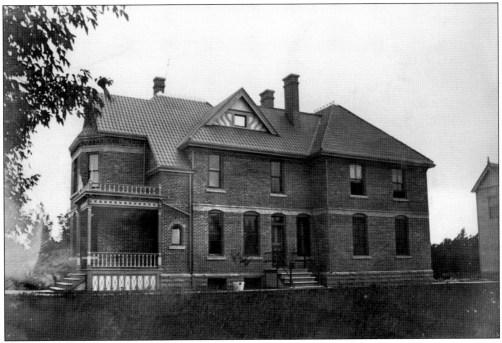

While this two-story, Victorian-style brick building looks much like a family home, it actually served as the first jailhouse for Brookings. The sheriff was able to keep a close eye on his inmates as he and his family resided upstairs. (South Dakota State Agricultural Heritage Museum Photographic Collection.)

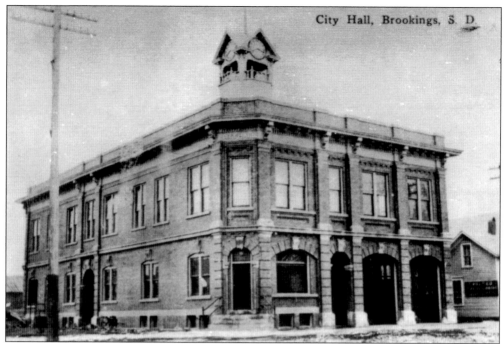

Home to the police and fire departments, city offices, and the Commercial Club, the city hall building was always buzzing with excitement. According to the National Register of Historic Places, this building was designed by Huron architect George Issenhuth and was constructed in 1912 by Brookings builders Wold and Johnson for $25,000. The police and fire departments moved in the 1960s and the city offices in the early 1980s. (Donna Ramsay.)

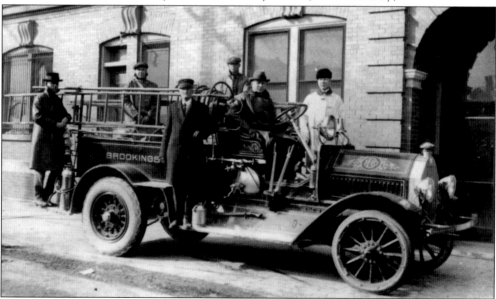

The fire department was organized in 1880 and was originally comprised of 12 volunteer men. This photograph, dating back to 1917, shows one of Brookings's first mechanical fire trucks. This picture was taken outside the city hall building where the fire department called home. The Brookings Fire Department is still a volunteer organization. (Donna Ramsay.)

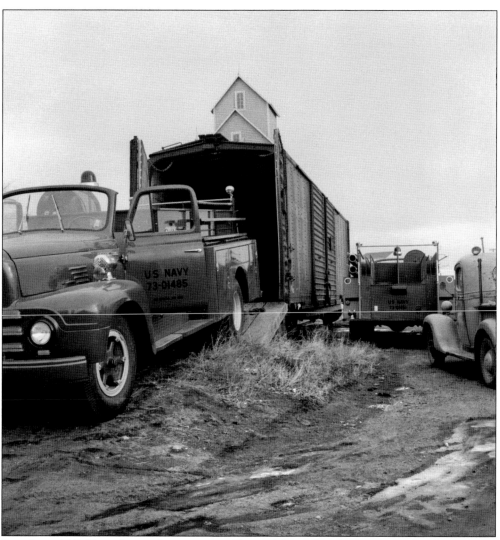

Brand-new U.S. Navy fire trucks are pictured being delivered to the Brookings Fire Department shortly after the war. It was common practice for the surplus vehicles from war to be sent across the country for other uses. (SDSU Archives.)

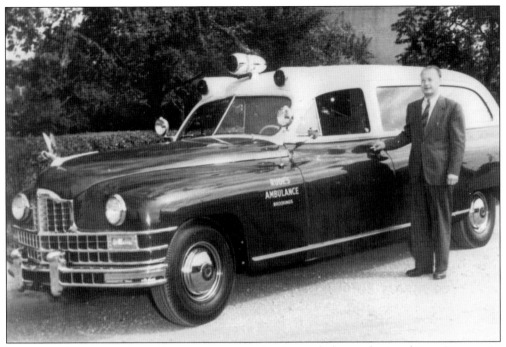

Vernon Rude is pictured standing next to one of the first ambulances for Brookings County. As the operator of Rude's Funeral Home, Rude was also one of the men responsible for ambulance service in Brookings. (Rude's Furniture.)

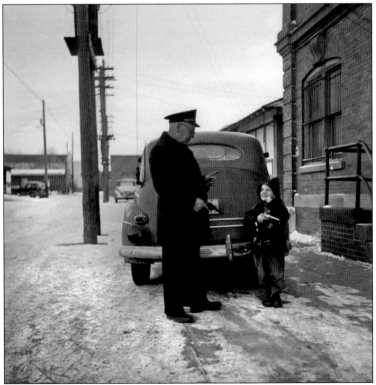

A Brookings police officer teaches a young boy firearm safety outside the old city hall building. (SDSU Archives.)

The Brookings fire chief addresses his fellow firefighters in this 1951 photograph. He was one of the few paid firemen for the City of Brookings. The district fire convention was being held in Brookings that year and brought in firefighters from all over South Dakota. Notice the fire truck parked on the left side of the street. (Donna Ramsay.)

Some of Brookings's rural mail carriers are pictured here in 1955. On the back of the photograph the men are labeled, from left to right, as Ralph H. Billick, Carl E. Fletcher, and Henry F. Grommersch. The three men are standing outside the post office preparing for their daily routes. (SDSU Archives.)

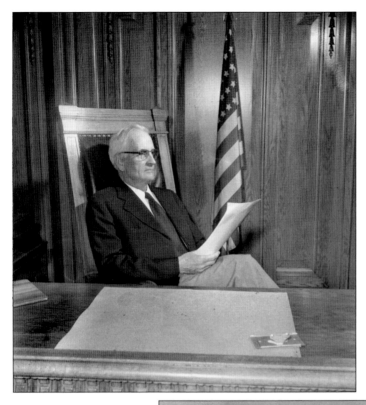

This 1953 picture of Judge Knight shows him sitting in the judge's chair in the courtroom of the Brookings Courthouse. The courtroom is located on the third floor of the building. This same courtroom is still used by the judges and lawyers of Brookings County. (SDSU Archives.)

In this 1952 picture, Sgt. John Cooper is seen standing in his uniform after receiving the Bronze Star. The Bronze Star is awarded for meritorious service, bravery, and acts of merit to individuals in the U.S. Armed Forces. It is an award of distinction, and Cooper wears it proudly. (SDSU Archives.)

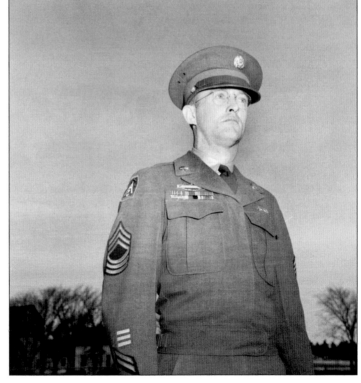

Four

BEANS, CORN, HORSES, AND COWS

While South Dakota offers a variety of landscapes and is well known for the stunning Black Hills, it is no secret that it also has acres of farmland. As news of cheap land spread in the late 1800s, settlers made their way across the plains toward the Dakota Territory. By the early 1900s, many families had started homesteads in South Dakota. In the early years, farmers encountered several setbacks, including the grasshopper scourges from 1873 to 1878 and drought years in the 1890s and 1930s. Through it all, the farmers of South Dakota have persevered.

The eastern part of South Dakota is primarily devoted to growing crops such as corn, wheat, and beans, while the western part of the state is considered ranchland where a variety of different animals are raised. Some ranchers have broadened their scope over the years by raising buffalo, elk, and even llamas. Raising these rare animals brings in a bigger payday than cows or sheep.

As times change, so have the crops that grace the fields of South Dakota. Many farmers now grow soybeans, which are made into oil. Corn has also found a new function as it is now used to make ethanol at one of South Dakota's many plants.

One tradition many farmers and ranchers strive to hold on to is that of passing their businesses on to family members. As farming seems to be more difficult and less financially beneficial, many South Dakota farmers pride themselves on the crops and livestock they produce each year. The fields surrounding Brookings are ripe with corn, beans, soybeans, and wheat. Farming is still an important part of the community, and many of the local farmers benefit from the research conducted at SDSU.

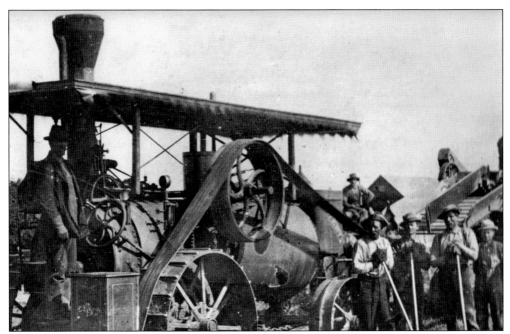

This early-1900s photograph shows a threshing machine farmers used to separate the grain from the stalks and husks. This process was done by hand until the invention of the thresher in the late 1700s. A thresher was an essential piece of farm equipment, and farmers borrowed one from a neighbor or family member if they did not have their own. (Brookings County Museum.)

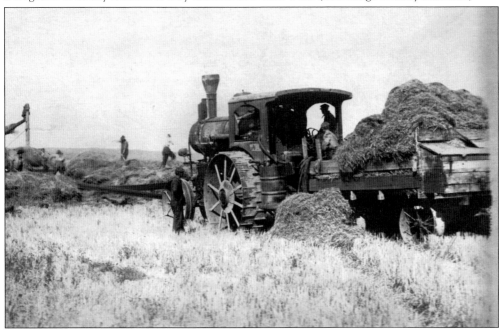

Neighbors and relatives often helped each other out during harvest season. This 1910 photograph is of the Homer Ponto farm and shows several relatives using a threshing machine. While the thresher made harvesting easier, it still took a large group of people to get the work done. (Brookings County Museum.)

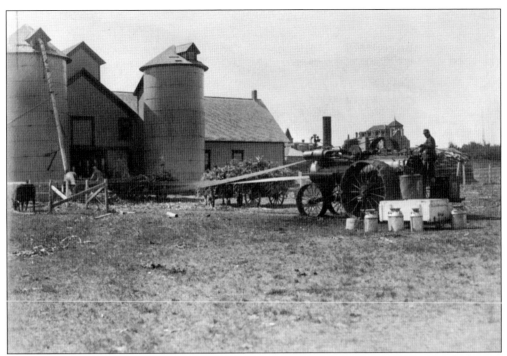

While SDSU has expanded far beyond its agricultural roots, this early-1900s photograph shows a steam engine outside one of the campus's barns. Since SDSC was started as a land-grant institution, the college owned and operated several farms. Old North and Old Central can be seen in the background. (SDSU Archives.)

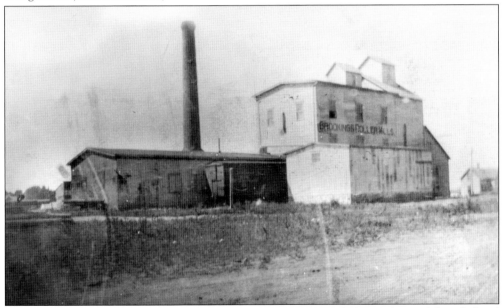

Roller mills were a crucial element for any town because they provided manufactured flour for local customers. This picture shows the Brookings Roller Mill, which had a railroad car park between the buildings. George Sexauer bought the Brookings Roller Mill in 1897, and the Sexauer family stayed in the business for several generations. (Brookings County Museum.)

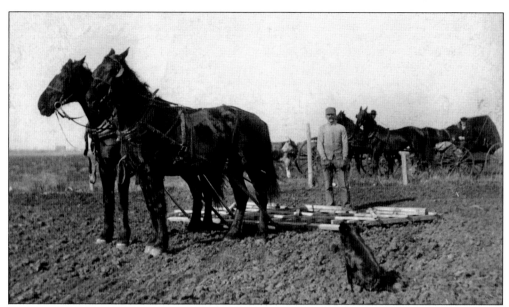

A farm scene in Brookings County is depicted in this March 12, 1900, photograph. It shows a harrow or drag being pulled by a team with buggies in the background. It was evidently a mild or early spring in 1900 as they were able to work in the fields in early March. (Brookings County Museum.)

Along with agriculture, animals such as horses were a large focus for students and faculty at SDSC. In this 1908 photograph, one of the college's greatest stud horses, Casino, is seen with his handler. It states that Casino is two years and 10 months old on the side of the photograph. (SDSU Archives.)

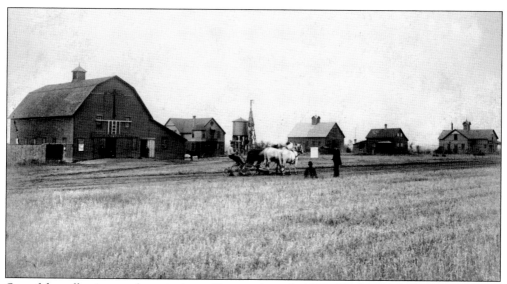

One of the college's many farms is pictured here in the early 1900s. The horses are dragging a harrow and preparing the field for planting. Farmers who grew crops and took care of livestock for the college were given government funds and some of the best farmland in the area. (SDSU Archives.)

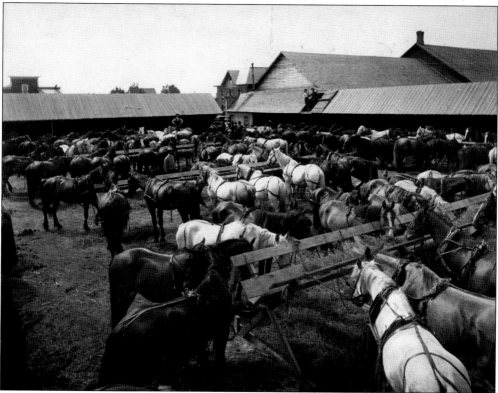

McElmurry's Stable, located one block from Main Avenue, appears to be an early version of the modern-day parking lot. This picture illustrates the vast amount of horses the stable could care for. On this occasion, farmers from around the county had gathered to enjoy the circus that had come to town. (South Dakota State Agricultural Heritage Museum Photographic Collection.)

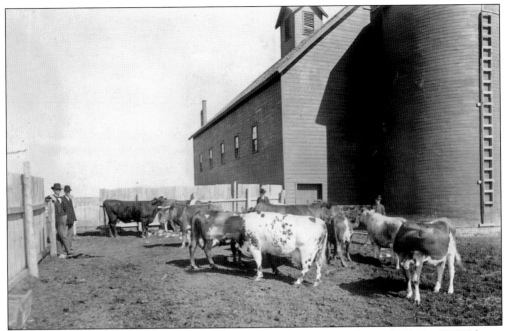

This photograph of one of the college's cattle barns dates back to the early 1900s. SDSU has a long history of studying livestock and milk production. The university still conducts research and experiments into how different environmental factors affect milk production and quality. The school also produces its own cheeses and ice cream on campus. (SDSU Archives.)

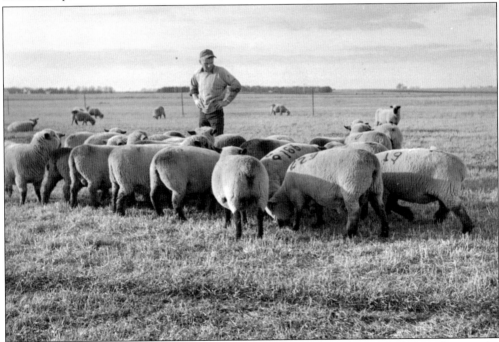

Hugh Barnett is pictured here in the early 1950s surveying his flock. Notice the numbers on the sheep. While sheep are not a common sight in the area now, several farmers tried their hand at raising them throughout the years. (SDSU Archives.)

A Mrs. Schultz is picking sweet corn from the field outside of her house in this 1951 photograph. Sweet corn grows rampant in South Dakota fields, and many residents swarm to farmers' markets for their share every summer. (SDSU Archives.)

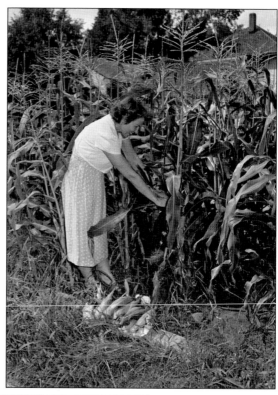

This early-1950s photograph shows the farmers' co-op located next to the railroad tracks on the south end of Main Avenue. The farmers' co-op was a busy place during the spring and fall months as local farmers came to town to get the best prices for their crops. (SDSU Archives.)

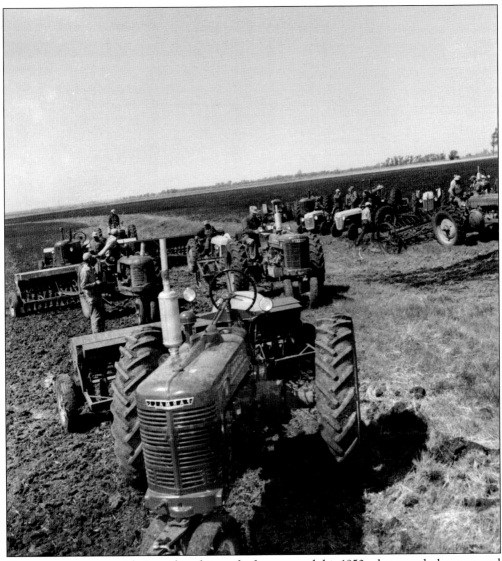

Tractors were an essential piece of machinery for farmers, and this 1950s photograph shows several farmers with their tractors. Neighbors would gather all of their equipment and help each other with fieldwork in the spring and fall. (SDSU Archives.)

Five

GATHERING PLACES
AND FAMILIAR FACES

As settlers left their homes and made their way across the Midwest, they found comfort in the familiar sight of churches and gathering places that offered the promise of community or a sense of belonging. Many of the congregations started in the 1880s in Brookings are still thriving parts of the city and continue the tradition of giving back to the community. There are more than 15 active churches open in Brookings today.

In the early years of its conception, Brookings prided itself on its beautiful homes and even advertised that it was the "City of Homes." The majority of those foundational homes still stand in Brookings, and walking through the city's historic district illustrates why Brookings residents felt such pride. Several architectural styles and elements are still visible, as homeowners have restored many of the homes to their original style.

While some of the foundational members of Brookings have long since moved on, many of the family names that were here in the late 1800s can still be seen on businesses. The Fishbacks, Rudes, and Sexauers are just a few of the families that helped start the city and stayed in Brookings. Over the years, many people have dedicated themselves to the betterment of the community.

As Brookings continues to grow, so does the variety of organizations. The food pantry, domestic abuse shelter, Meals on Wheels, the Harvest Table, and the Boys and Girls Club are just a few of the organizations that now offer a gathering place or familiar face to help those who need it.

The First Norwegian Evangelical Church was built in 1886. Marcus Johnson erected this structure for $2,500. In 1888, a parsonage was constructed next to the church for an additional $1,500. This congregation served as the only Lutheran organization in Brookings until the late 1920s. (South Dakota State Agricultural Heritage Museum Photographic Collection.)

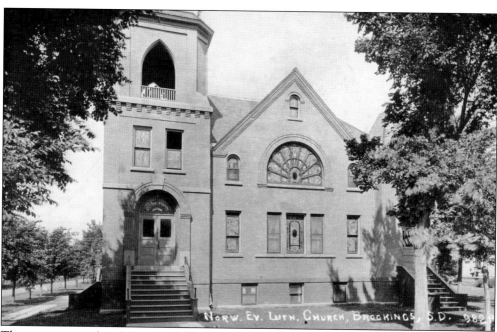

This structure replaced the above church in 1908. The cost of the building and fixtures was estimated at $12,000. In 1923, the organization became the First Lutheran Church of Brookings. This building was sold in 1958 to the Bethel Baptist congregation. The angle of this photograph shows the beautifully designed stained-glass windows. (Rude's Furniture.)

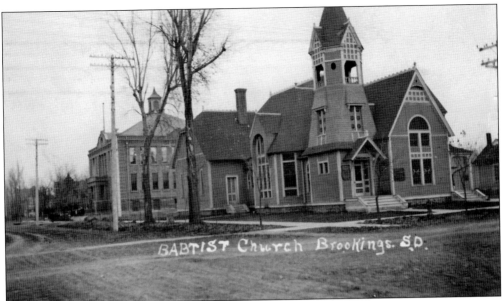

The Baptist organization can be traced back to the early 1880s in Brookings. This building was constructed in 1882. While this structure underwent some additions, the congregation eventually outgrew it and built a new church in 1918. The auxiliary school can be seen standing behind the church in this photograph. (Rude's Furniture.)

The Presbyterian congregation, organized in 1882, used the Olds and Fishback Hall for services. The first church was built in 1885, but as the congregation soon outgrew it, Horace Fishback Sr., F. J. Carlisle, William A. Caldwell, J. W. Middleton, and George Sexauer formed a committee to raise money for a new church. This church was dedicated in 1901 and contained the first pipe organ in Brookings. (Brookings County Museum.)

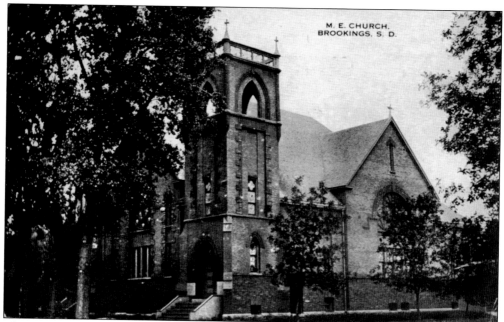

The Methodist Episcopal Society is one of the oldest religious organizations in Brookings, dating back to 1879. In 1880, the society built its first church, and in 1881 it became incorporated as a Methodist church. The church in this photograph was erected in 1904 in order to house the growing congregation. (South Dakota State Agricultural Heritage Museum Photographic Collection.)

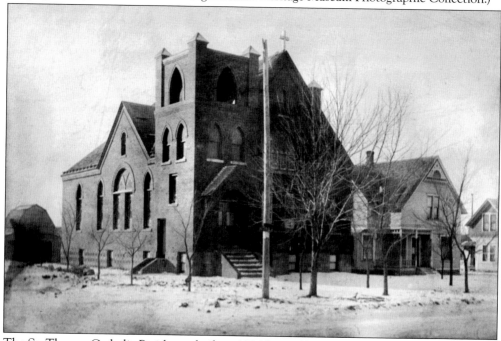

The St. Thomas Catholic Parish was built in 1906 by Wold and Johnson Construction at a cost of $7,000. The congregation purchased two lots in the Skinner's Addition II so they could also build a rectory, which can be seen next to the church. The first pastor to reside in the rectory was the Reverend William Shean. (STM Collection.)

George Rude was one of the founding fathers of Brookings. Born in Norway, Rude immigrated to Iowa with his family before moving to Brookings in 1878. In 1881, he opened a hotel called the Christiana House. Eventually Rude became the manager of Rude's Furniture after his brother Ole Rude passed away in 1901. (Rude's Furniture.)

Bert Rude, one of George's sons, was the second-generation owner of Rude's Furniture. By 1938, Bert was the sole proprietor of the furniture store and Rude's Funeral Home, which was located in the Masonic temple. Bert's son Vernon eventually took over the funeral home, and another son, Duane, became the owner of the furniture store. (Rude's Furniture.)

George Mathews, a prominent lawyer and politician, moved to Brookings in 1879 with his partner John O'Brien Scobey. Mathews played an important role in the development of Brookings and held several local and territorial government positions. In addition, he helped to establish a municipal ownership of all utilities and required the planting of trees on boulevards. (Fishback family.)

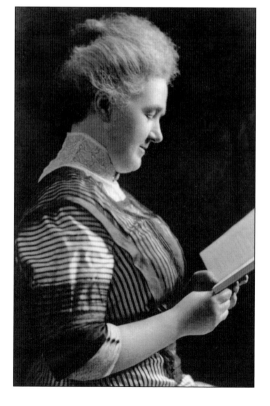

Bertha Van Dusen was George Mathews's second wife. The couple married in 1892. Bertha's sister Cornelia lived next door with her husband, Horace Fishback Sr. This picture is a unique illustration of the dress common for upper-class women in the late 1800s. Note that she is not facing the camera and appears to be reading. (Fishback family.)

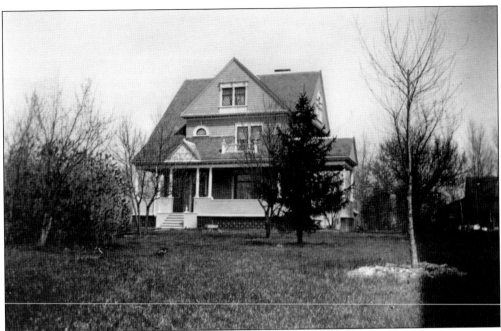

George Mathews built this home in 1896 shortly after his marriage to Bertha Van Dusen. This Queen Anne–style home, built by contractor A. D. Mower, is a great example of the architecture common in the late 1800s. Mathews and his family lived in this home until sometime in the 1920s. (Fishback family.)

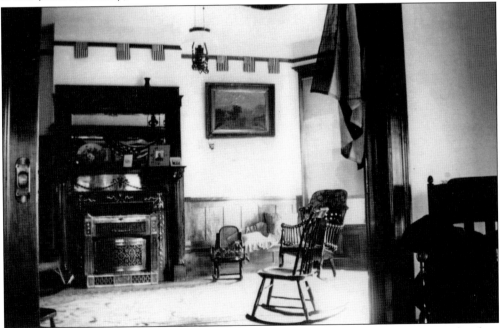

This photograph shows the inside of George and Bertha Mathews's home. The ornate fireplace serves as the centerpiece of the living room. Mathews's dedication to his country is evident in his decor as flags hang from the crown molding. A large flag can also be seen draped in the doorway that connects the sitting room and the living room. (Fishback family.)

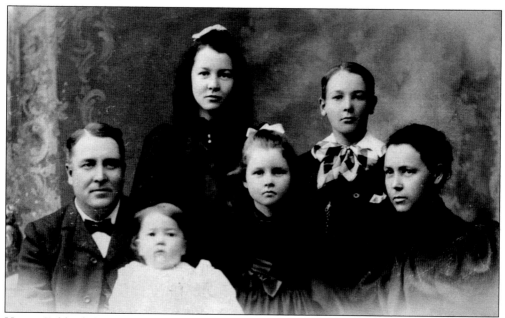

Horace Fishback Sr. came to Brookings in 1880 and instantly became a substantial member of the community. While he is best known for his banking developments, Fishback also generously gave of his time and money to several community enterprises. The members of the Fishback family are Horace Sr. with Horace Jr. on his lap, and Cornelia Dusen Fishback seated on the right-hand side; standing from left to right are Myra, Blanche, and Van. (Fishback family.)

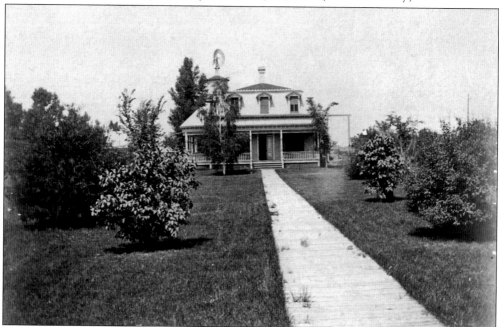

This 1899 photograph illustrates Horace and Cornelia Fishback's first home in Brookings at the north end of Main Avenue. Instead of having the house torn down, Horace had this house moved about a block away so he could build his family home, which is widely known today as the Horace and Cornelia Fishback mansion. (Fishback family.)

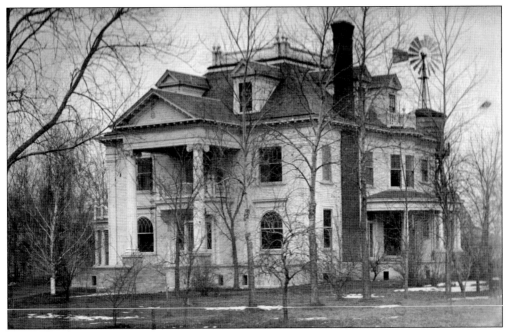

After establishing a general store with his uncle A. B. Olds, which housed the first banking institution for Brookings, Horace Fishback Sr. had this impressive neoclassical-style home built in 1902. This picture shows the east side of the house and highlights one of the impressive chimneys and the original windmill and water tower. (Fishback family.)

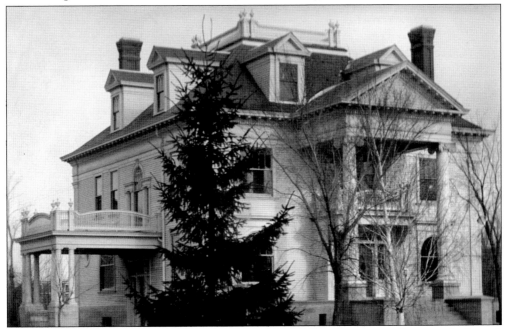

This photograph, showing the front and west side of the Fishback mansion, illustrates the home's pedimented portico with its elaborate Ionic columns. This impressive home has remained in the Fishback family since it was built. Currently Barbara and Van Fishback continue the home's upkeep. It still contains many of its original furnishings. (Fishback family.)

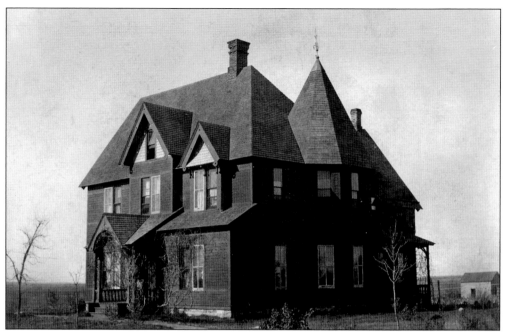

Built in 1887 by the college's second president, Dr. Lewis McLouth, Woodbine Cottage is a prominent fixture on the SDSU campus. This structure has housed most of the SDSU presidents and their families. It also served briefly as a women's dormitory, a music hall, and even an infirmary. (SDSU Archives.)

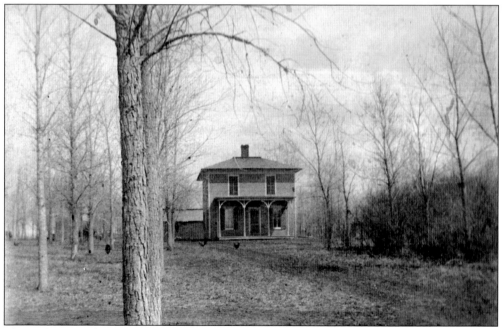

This early-1900s photograph shows the vast amount of property homeowners had at the beginning of the 20th century. This simple, two-story structure is known only as Ed Hart's house according to the writing on the back of the original photograph. Notice the chickens wandering freely around the front yard. (Brookings County Museum.)

90

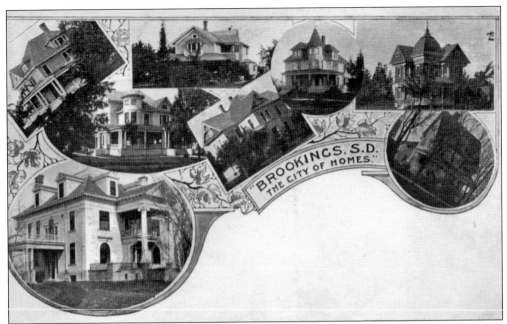

This vintage, late-1800s postcard depicts the unique and upscale homes being built in Brookings. At that time, most businessmen could afford to build their own homes given the low cost of materials and land. Advertisements for the city emphasized the cleanliness of Brookings and the pride homeowners took in their beautiful homes. (Rude's Furniture.)

This two-and-a-half-story home was built in the early 1900s. The house was constructed for G. F. and Anna Knappen. This picture was taken on May 26, 1906, and shows the Knappens on their porch receiving visitors. G. F. was a cashier at the Bank of Brookings. (Shari Thornes.)

This early wood-frame house was built in 1902 for George Morehouse. Morehouse was one of the first bankers in Brookings and opened the Bank of Brookings in the 1880s. Unfortunately this house was razed for the construction of Pugsley Student Union on the SDSU campus. (South Dakota State Agricultural Heritage Museum Photographic Collection.)

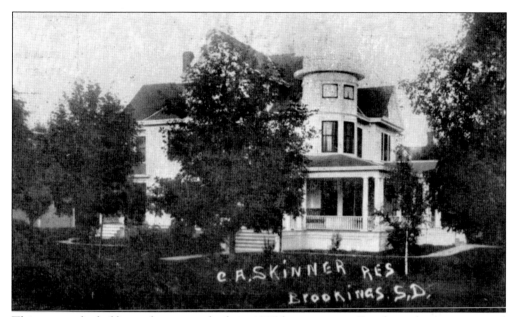

This two-and-a-half-story house was built in 1905 by prominent Brookings businessman and philanthropist Charles Skinner. At that time, there were only a few houses between the Skinners' house and the college. One of the standout features of this house is its central tower. This neighborhood was named the Skinner Addition. (SDSU Archives.)

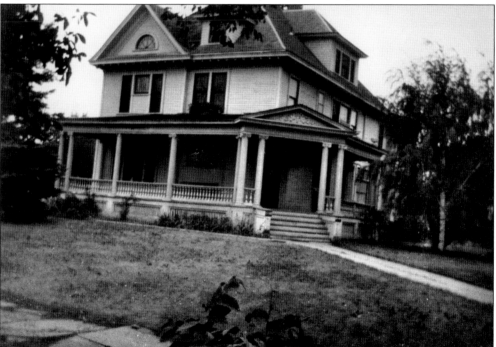

This home was built in 1902 for William A. Caldwell, the president of Farmer's National Bank. It is a significant structure that exemplifies neoclassical architecture. The prominent portico is supported by several large columns. In 1929, the home was converted into seven apartments. (South Dakota State Agricultural Heritage Museum Photographic Collection.)

Built in 1906, this house illustrates the typical Queen Anne architecture common in the early 1900s. While this home and barn were built by a carpenter named Williams, it became known throughout Brookings as the Peterson House. Some of the unique features include the turret, gables, and gingerbread latticework. (Larry and Diana Zwieg.)

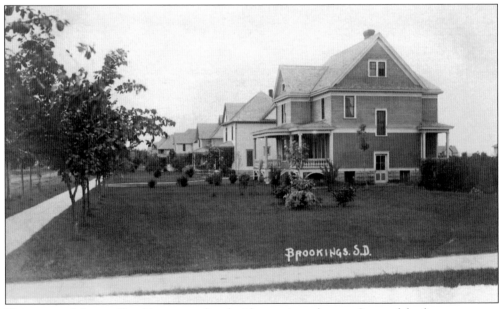

This postcard shows a Brookings street lined with prominent homes. Some of the first newspaper coverage of Brookings called it the "City of Homes," which this postcard shows. The boulevard was lined by many trees, illustrating George Mathews's vision of tree-covered streets. Notice that this residential area has paved sidewalks and meticulously maintained lawns. (Rude's Furniture.)

Six

ON THE GO

Modes of transportation have certainly evolved over the years as settlers made their way to the area on horseback and in covered wagons, and now this society searches for alternative fuels and drives hybrid cars.

The founders of Brookings generally walked the short distance from their homes to work on Main Avenue. For longer distances, they would use horse-and-buggy teams or take the train. As automobiles became more affordable, they became the preferred form of transportation and a status symbol of success.

Bringing the railroad to Brookings was elemental in the transformation of Brookings from a homestead village. The Brookings Station was opened for business on November 17, 1879. In the first month of business, the station received 36 cars of freight, which no doubt contained lumber and other materials needed for new houses and businesses.

The city's first airport was constructed sometime in the mid-1900s. Over the years, the amount of flights offered has diminished, but several local pilots keep their airplanes there for personal use. They can be seen on nice days buzzing the skies over Brookings.

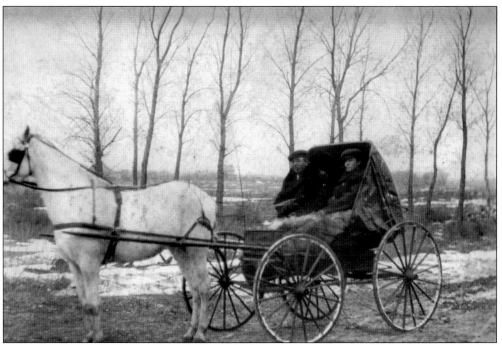

A horse and buggy belonging to the Ponto family is shown in this late-1800s photograph. The couple in the buggy could have been headed to town for groceries or simply out for a Sunday ride. The horse-and-buggy combo was the main form of transportation at that time. (Brookings County Museum.)

This 1909 photograph depicts a South Dakota State College employee and one of the school's horse-and-buggy teams. The land he is looking at is the future site of Wenona Hall and Wecota Hall, dormitories built in the early 1900s that still stand on the west side of the university's campus. (SDSU Archives.)

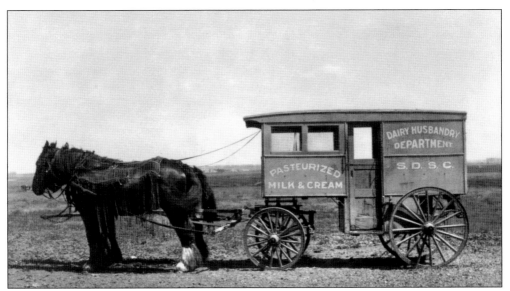

This 1907 photograph of the SDSC dairy delivery truck illustrates an early version of the modern-day delivery trucks that now crowd Brookings's Main Avenue. The college had several working farms and often sold the crops and milk for revenue. This delivery truck was one of the first vehicles owned by the college. (South Dakota State Agricultural Heritage Museum Photographic Collection.)

Bert Rude, pictured on the far left, loved his horses and brought them out to ride even when he lived on the north end of Main Avenue. While he did own a car, he never wanted to give up his horses, so he kept them close by in the barn. (Rude's Furniture.)

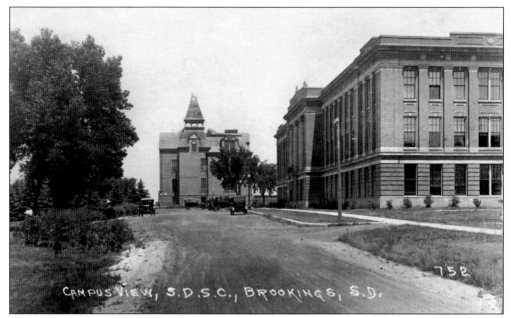

This 1925 postcard of the SDSC campus shows some of the modern cars parked outside. The college officials often had to travel out of town for meetings, and cars were the preferred method of transportation by 1925. Students would not have had cars on the campus yet, which meant they did not have to deal with SDSU's current parking issues. (Rude's Furniture.)

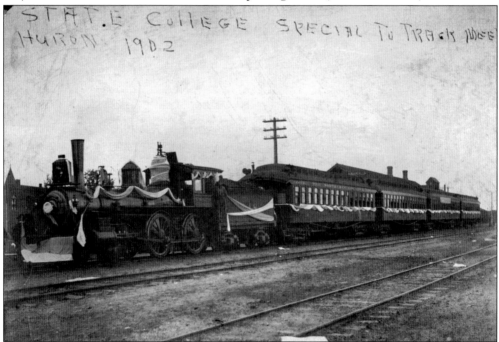

Athletes from South Dakota State College traveled by train to neighboring towns in order to compete in sporting events. This picture, taken in 1902, shows the train leaving the Brookings depot bound for Huron for a college track meet. The train is decorated to announce the arrival of the athletes. (South Dakota State Agricultural Heritage Museum Photographic Collection.)

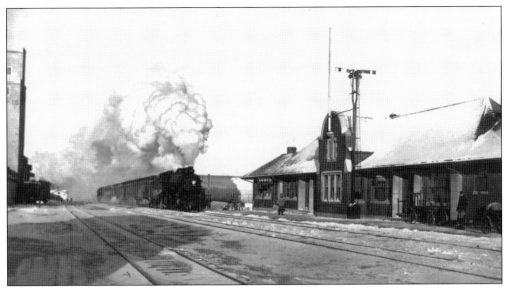

The Chicago and Northwestern Railway passenger depot began as a simple wood-frame building that opened for business in November 1879. W. H. Skinner is credited with bringing the railroad to Brookings. The above depot building was dedicated on February 1, 1905. (Doris Roden.)

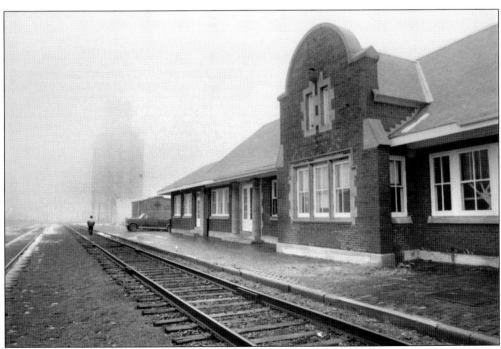

Built in 1904, the Chicago and Northwestern Railway passenger depot was the site of many historic events in Brookings. This structure was built using No. 1 Continental brick and Kasota-cut stone, replacing the earlier wooden building. While this structure no longer serves as a depot, it has been preserved through the years and still stands in downtown Brookings. (SDSU Archives.)

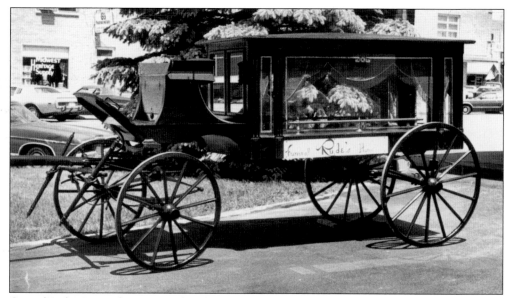

One of Rude's Funeral Home's earliest hearses is pictured here in the early 1900s. Before cars and trucks were available, caskets had to be transported through the use of horse-drawn wagons. Notice the windows on the side of the wagon that allow a clear view of the casket. (SDSU Archives.)

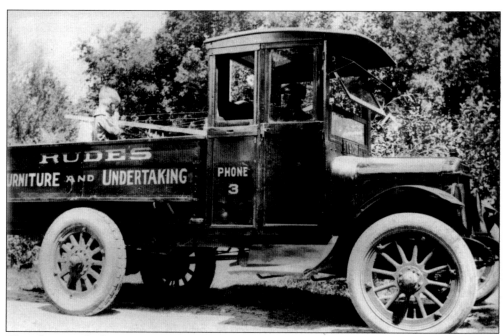

This photograph shows the Rude's Furniture and Undertaking delivery truck. It was common for furniture stores to also be involved in undertaking because they were often responsible for building the caskets. Since that was the case, this truck served double duty delivering furniture and caskets. John Nothe is standing in the back of the truck and Orin Rude is the driver. (Rude's Furniture.)

One of the first automobiles to come to town is being proudly displayed by its owner on Main Avenue in Brookings. Having a car was a status symbol and made this man popular. (Brookings County Museum.)

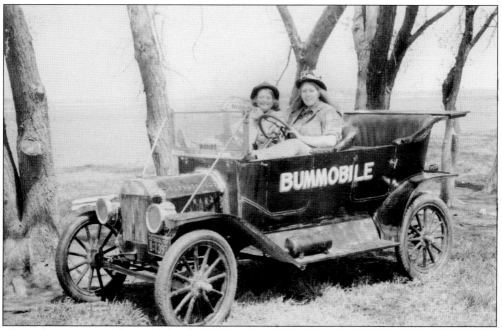

The infamous SDSU bummobile is pictured before one of its many appearances in the Hobo Days parade. The bummobile still makes its way through the Hobo Days parade route carrying the Hobo King and Queen. (SDSU Archives.)

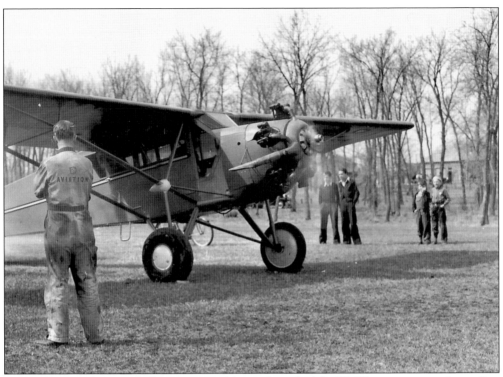

This early-1930s photograph illustrates one of the airplanes built by SDSU aeronautics students. One of the students stands to the left of the plane to watch its maiden flight. (SDSU Archives.)

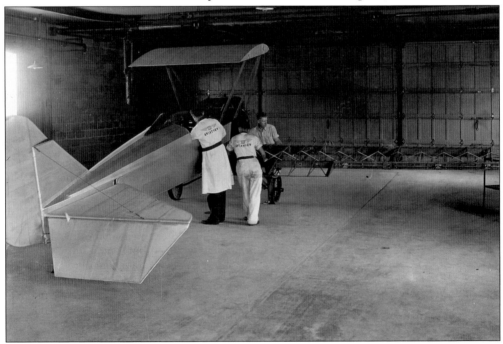

Aviation cadets are captured building an airplane in the Curatun Lab in this 1936 photograph. SDSU still has an active aeronautics program. (SDSU Archives.)

The Kallemeyn Dairy delivery truck is getting ready for the daily deliveries in this picture. While the trucks have certainly gotten bigger and have tanks to keep the milk cold, deliverymen or truck drivers are still an essential part of any community. They bring the product from the farms to the plants to be processed and then to the stores for sale. (SDSU Archives.)

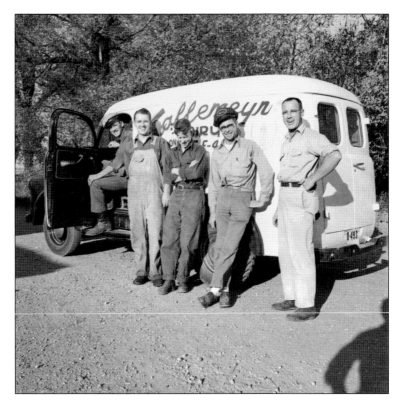

One of Bert Rude's first cars is parked outside his house on north Main Avenue. While Rude did like his horses, he was also fond of his car. (Rude's Furniture.)

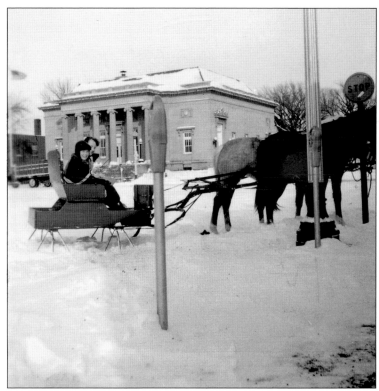

This 1952 picture was taken after a blizzard made its way through eastern South Dakota that February. Even in the 1950s, many Brookings residents made their way around town by using sleds and horses because it was easier and more fun then trying to navigate an automobile. (SDSU Archives.)

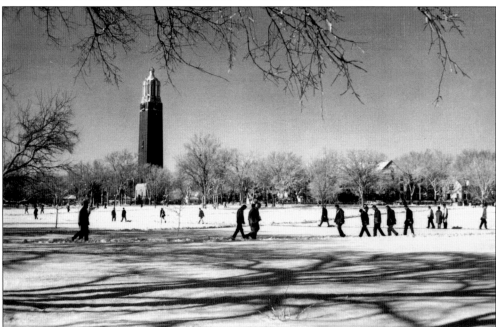

For several decades, SDSU students made their way to and from classes and activities by walking across campus. In the early years, they even had to hoof it over a mile to downtown Brookings. This picture shows students braving the cold and snow of winter to attend classes. (SDSU Archives.)

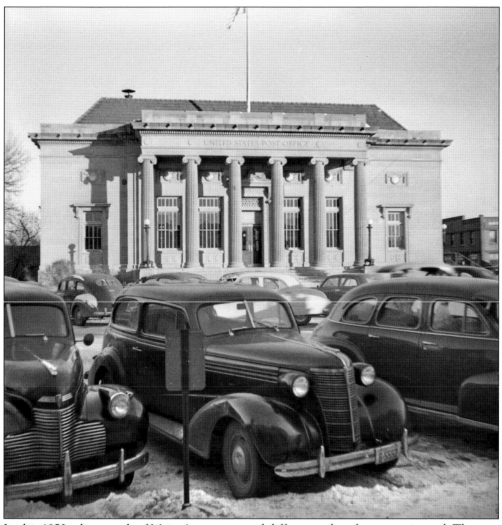

In this 1950s photograph of Main Avenue, several different styles of cars are pictured. The post office appears quite statuesque in the background. (SDSU Archives.)

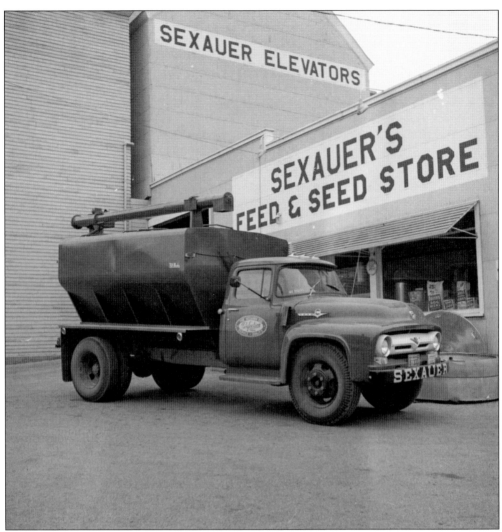

One of the many feed trucks for Sexauer's Elevators is shown here in the 1950s. The feed trucks transported the crops from the fields to the elevators. The feed could then be stored in the elevators or transported by train to destinations across the country. (SDSU Archives.)

Seven

Entertainment and Headlines

Every community has events and even disasters that bring people together in celebration or sympathy. Common among small towns, parades were a primary means of celebrating holidays and special occasions in the early years in Brookings. In times of disaster, friends and family would gather to pick up the pieces.

As the pictures in this chapter will show, the community and the college shared many important events over the years. President Calvin Coolidge came to dedicate Coolidge Sylvan Theatre, and people from all over the Midwest came to catch a glimpse of their leader. Military reviews and sporting events brought the community out and allowed them to share in the success of the college. Fans from all across South Dakota come to Brookings to support the SDSU Jackrabbits. One of the most prominent events that brought the community and college together was, and still is, Hobo Days.

While there has been much to celebrate in Brookings, the turbulent weather in South Dakota has caused many upsets. High winds, tornadoes, flooding, and severe winter storms have often brought the city to a standstill. In the early years, fire seemed to be the downfall of many buildings, leaving nothing but charred shells.

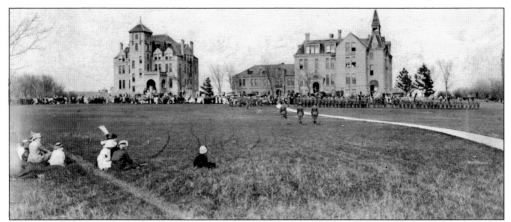

This early-1900s photograph shows the first three buildings that comprised the campus of South Dakota State College. The buildings from left to right are Old North, the Chemistry Building, and Old Central. The campus green served as a gathering place for students and people from throughout the community who came to watch military reviews and college activities. (SDSU Archives.)

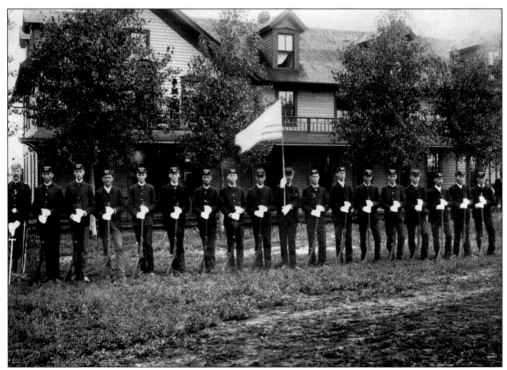

A group of cadets from SDSC poses for this early-1900s photograph in front of the hotel in downtown Brookings. The college and the people of Brookings were proud of these young men and took every opportunity available to watch them practice. A caption on the photograph states, "D. A. C. Cadets." SDSC was sometimes referred to as the Dakota Agricultural College. (SDSU Archives.)

Brookings County Fair. 1910

The Brookings County Fairgrounds attracted people from around the area to enjoy entertainment, homemade preserves, and baked goods. Farmers also brought their livestock to the fair for judging to see if they were higher quality and, thus, worth more money at sale. This early-1900s photograph shows the main buildings and part of the grandstand for the fairgrounds. (Brookings County Museum.)

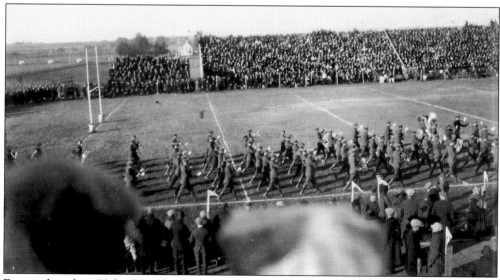

Fans gathered on Hobo Days for the football game were treated to a halftime performance by the SDSU Band. The SDSU Pride of the Dakotas still entertains fans at football games and has received national attention. The Pride has performed in the Rose Bowl Parade and in Washington D.C. (SDSU Archives.)

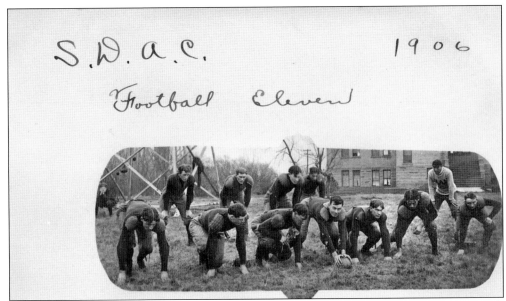

S.D.A.C. 1906
Football Eleven

SDSC joined colleges from Vermillion, Yankton, and Sioux Falls in 1889 to create the South Dakota Inter-Collegiate Athletic Association. The first state meet had baseball, football, bicycle races, tennis, tug-of-war, and track and field. This 1906 photograph shows some of the SDSC football members practicing for a game. (SDSU Archives.)

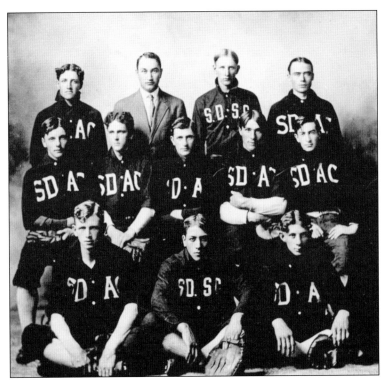

The SDSC baseball team is pictured here in 1908. Baseball and football were not only important to the students, but they also provided free entertainment for the citizens of Brookings and brought the school and community together. Notice that some of the uniforms have "SDSC" on them and others "SDAC," which stands for South Dakota Agricultural College as it was also called. (SDSU Archives.)

Since its beginning in the early 1900s, basketball has played an important role in SDSU athletics. These members of the 1926 team are, from left to right, (front row) Henry Schultz, Lloyd Amundsen, Lestor Lindbloom, Nelson Hess, and Ralph Zebarth; (back row) Charles Johnson, Walter Miller, and Claire Hopkins. (SDSU Archives.)

A rough patch made of grass and hay with a net spread down the middle served as the first tennis court for SDSC. This 1915 photograph shows a doubles match between a pair from SDSC and a pair from their number-one rival, the University of South Dakota (USD). Spectators sit by the buildings to watch. (SDSU Archives.)

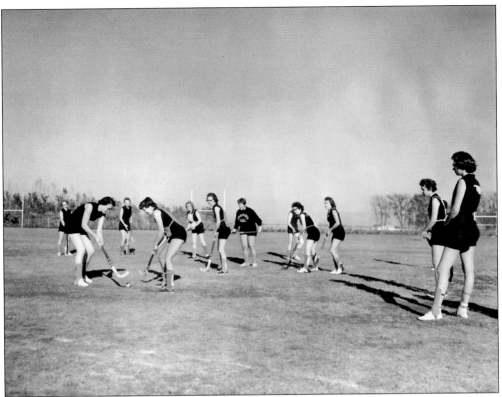

Field hockey was a popular sport in the early 1900s because it required little equipment and just an open field, which was readily available on campus. The SDSC women's field hockey team is pictured here in 1925 practicing for a match. (SDSU Archives.)

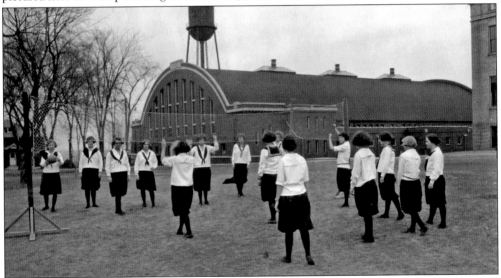

While volleyball has a long history at SDSU, the women's volleyball team has only recently received national attention for their accomplishments. In this early campus photograph, the women's team is pictured practicing on the campus green. Notice the long skirts and modest shirts that make up their uniforms. (SDSU Archives.)

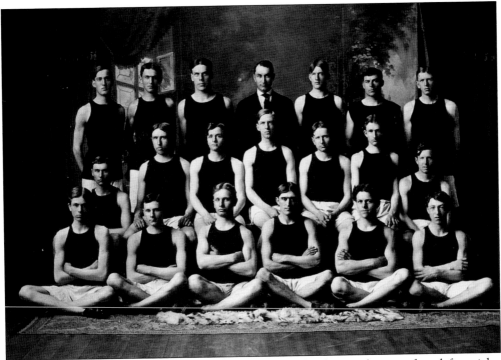

The 1906 track and field team poses for a team photograph. The members are, from left to right, (first row) Elmer Sexauer, Ralph Chilcott, Morris Jerlow, Thomas Smith, William Ladd, and Arthur Mathews; (second row) John Furnstahl, John Kirk, William Cooley, manager John Sperb, John Lockhart, Frank Sperb, captain Fred Coller; (third row) Ben Alton, Ross Elliott, Carl Reich, coach William Juneau, Albert Drew, Clare McCordic, and Charles Coughlin. (SDSU Archives.)

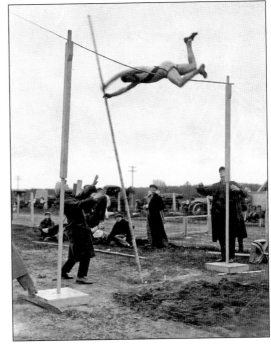

This SDSC athlete barely makes it over the bar during a high jump attempt as several men stand on the sidelines and watch. Notice that there is no mat for him to land on. Based on the height of the men standing next to the apparatus, the pole is at least 10 feet tall. (SDSU Archives.)

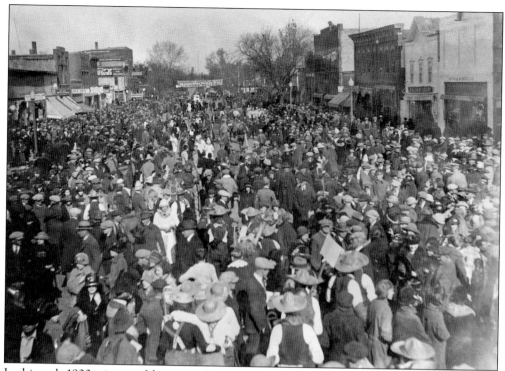

In this early-1900s picture of downtown Brookings, hundreds of people have gathered to celebrate the college's homecoming Hobo Days. This photograph illustrates the importance of Hobo Days for the downtown businesses of Brookings. A sign is hanging across Main Avenue that reads, "Brookings Commercial Club—Visitors Welcome." (SDSU Archives.)

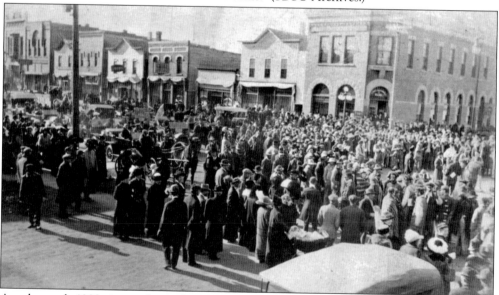

Another early-1900s image shows the crowds gathered downtown for Hobo Days. A variety of people are wandering the streets, with some dressed in their best clothes and others showing their Hobo Days spirit. Notice the Old First National Bank on the corner of Main Avenue and Fourth Street. (SDSU Archives.)

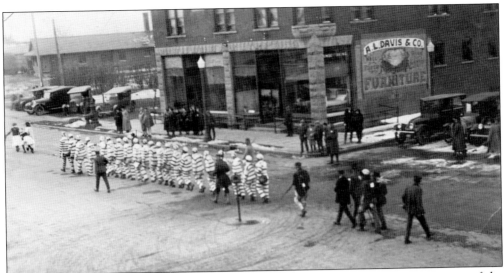

This 1920 picture shows several "prisoners" being marched down Main Avenue as part of the Hobo Days parade. A group of hobos follow closely behind the prisoners. Hobo Days is often cold for all involved because it is generally held in October. Notice the snow on the sidewalks and cars. (SDSU Archives.)

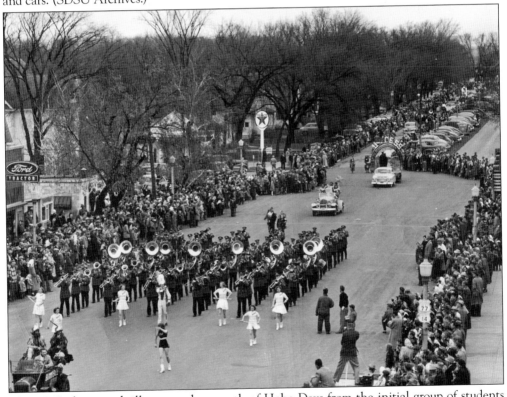

This 1949 photograph illustrates the growth of Hobo Days from the initial group of students gathered on the college lawn in 1912 to the massive crowds and parade members seen here. Hobo Days remains a popular event in Brookings, drawing thousands of people to town each fall. (SDSU Archives.)

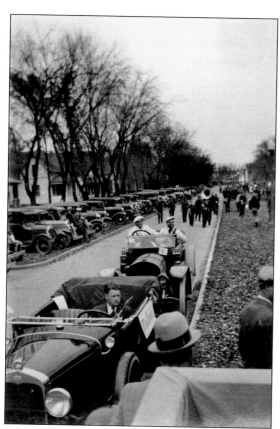

As the college and city grew in size, so did the Hobo Days festivities. This photograph shows parade members lining up on the north end of Main Avenue. College and city dignitaries, as well as the SDSC Band, were traditionally the first to make their way down Main Avenue. (SDSU Archives.)

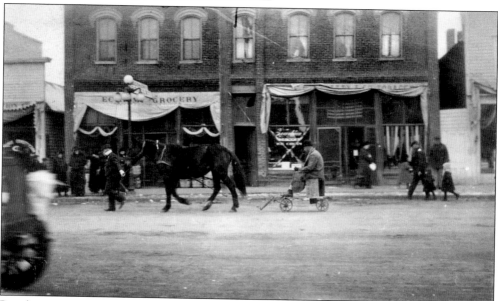

Parades were a common form of entertainment in the early 1900s and often occurred on Main Avenue. On this occasion, the circus came to town, and some of its members stirred up business by parading down Main Avenue. Notice the dress of the people standing on the sidewalks. (SDSU Archives.)

116

Several city officials lead this 1950s parade down Main Avenue on horseback. The buildings seen are on the west side of Main Avenue and are still standing today. Notice the width of Main Avenue, as there are cars parked on either side of the street and there is still plenty of room for the parade to get through. (SDSU Archives.)

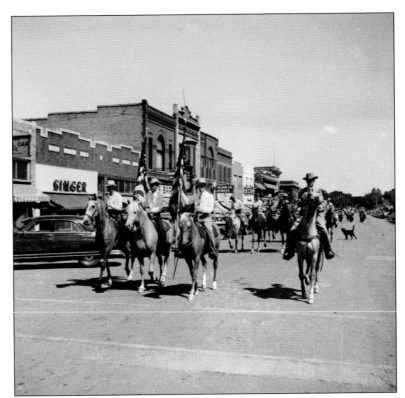

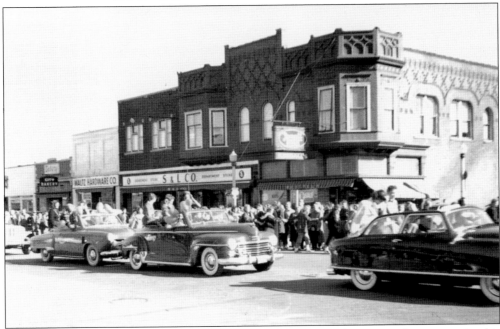

Prominent city and state officials are being driven down Main Avenue in elegant cars for this parade in the early 1950s. The building in the background is the Kendall Building (corner) and the S&L Company. Notice the people walking through the streets shaking hands; they may be part of a political group or campaign. (SDSU Archives.)

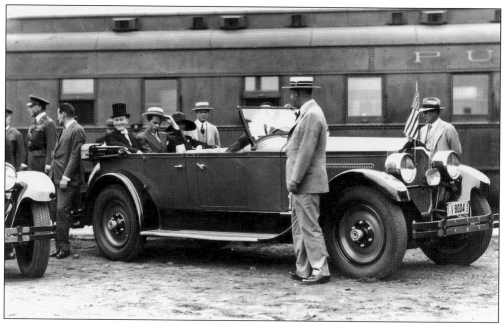

Few events in Brookings's early history were able to create a stir like Pres. Calvin Coolidge's visit in 1927. This picture shows the president arriving at the Brookings train depot and preparing to make his way to the college. Secret Service agents stand next to the car in light-colored suits, keeping a watch over the president. (SDSU Archives.)

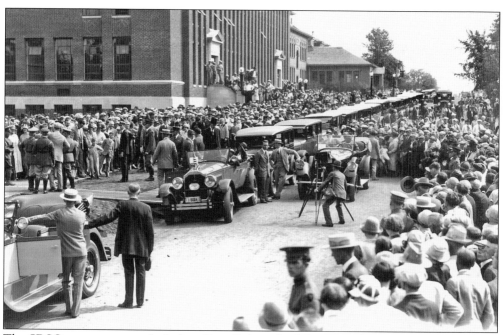

The SDSC campus was packed when Pres. Calvin Coolidge arrived in Brookings to dedicate Coolidge Sylvan Theatre. A long line of railcars arrived with the president carrying Secret Service agents, staff members, and other prominent dignitaries. The president can be seen standing in the back seat of his convertible wearing his top hat. (SDSU Archives.)

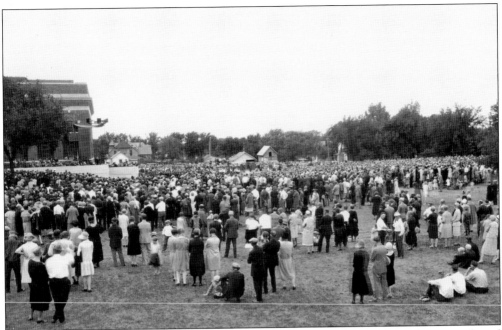

This photograph is of the campus green in front of Old Central. The view is facing north and shows the massive crowd gathered in September 1927 to see Pres. Calvin Coolidge and his wife, Grace, dedicate the Coolidge Sylvan Theatre. People of all ages can be seen scattered throughout the crowd. (SDSU Archives.)

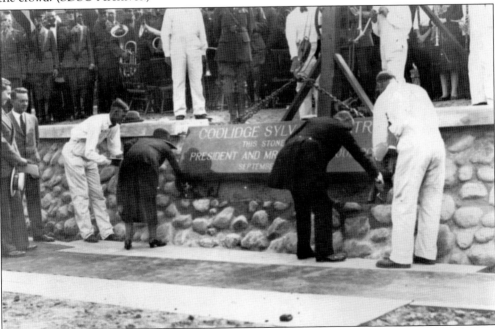

President Coolidge and his wife are laying the memorial stone for the Coolidge Sylvan Theatre. The stone is still there, commemorating that eventful day in 1927. Brick masons in white uniforms stand on either side of the president and his wife to help them with the process. Notice the large chains and pulley system holding the stone in place. (SDSU Archives.)

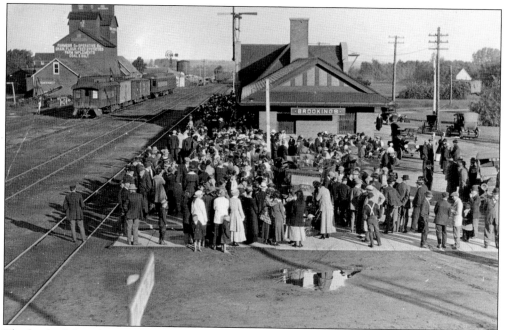

The back of this photograph of the Brookings depot reads, "June 23, 1916 before boys arrive at depot." Family members gather to greet their sons, brothers, and husbands as they return from training or active duty. Over the years, the depot served as the site for many good-byes and welcomes for troops. (South Dakota State Agricultural Heritage Museum Photographic Collection.)

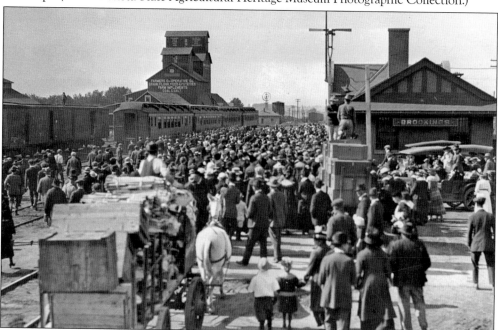

This photograph shows the train depot after the train has arrived. According to the handwriting on the back of the original photograph, people have gathered in June 1916 to welcome home troops from the Mexican border. Men in uniforms can be seen standing next to the passenger cars. (South Dakota State Agricultural Heritage Museum Photographic Collection.)

While President Coolidge's visit was a highlight and major event for Brookings, another president also graced Brookings with his presence. In 1952, Dwight D. Eisenhower made a stop at Brookings Airport during his presidential campaign. Eisenhower is pictured on the right-hand side. His airplane, the "Eisenhower Special," can be seen in the background. (SDSU Archives.)

This photograph dates back to June 1952 and shows how city officials kept track of election results. Along the left-hand side of the chalkboard, the names of all of the cities within Brookings County can be seen. The spots on the top of the chalkboard list the names of the candidates and the position they are running for. (SDSU Archives.)

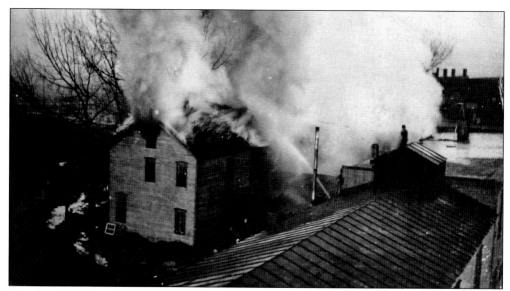

Fires were a common occurrence in the early years of Brookings, claiming many of its oldest buildings. This photograph shows the Brookings House Hotel fire that broke out in the early morning hours of March 19, 1910. The Brookings Fire Department fought the burning building but little remained. (Brookings County Museum.)

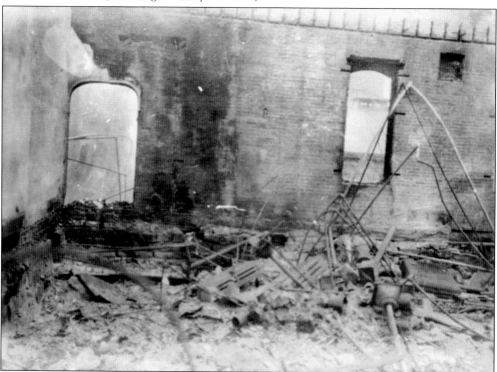

Several of the buildings on the SDSC campus fell victim to fire and were destroyed over the years. Built in 1897, the Chemistry Building burned in the winter of 1928. Unfortunately the water froze almost immediately in the cold. This photograph illustrates what was left after firefighters tried to stop the blaze. (SDSU Archives.)

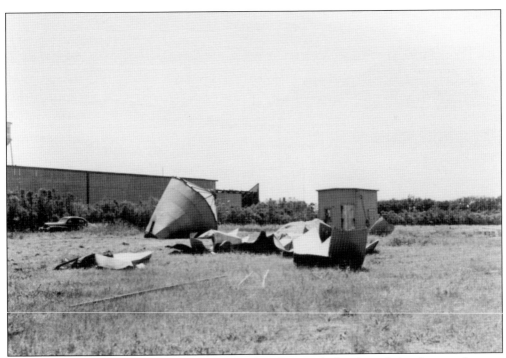

High winds and tornadoes are common in South Dakota and often leave behind severe damage. The above photograph from 1947 illustrates storm damage to some steel bins on the college campus. The photograph below shows the roofs ripped off of some of the campus buildings after the same storm. (Both SDSU Archives.)

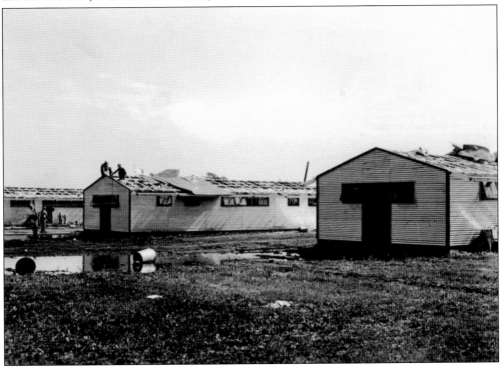

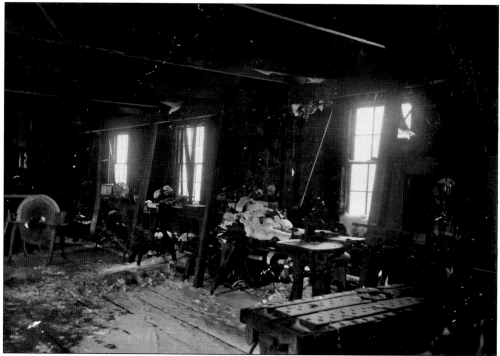

This February 1897 photograph illustrates the conditions students and faculty faced during the early years of the SDSC campus. The machinery room was located in the basement of the Industrial Arts Building and had a visible accumulation of snow on the ground. (SDSU Archives.)

Winter can be harsh in South Dakota, but spring can also prove treacherous as this April 1929 photograph shows. Spring blizzards are commonplace in South Dakota, bringing several feet of snow in a short period of time. This photograph of the campus green shows a large volume of accumulated snow. (SDSU Archives.)

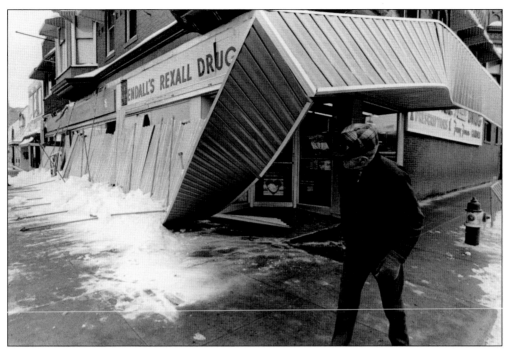

High winds and flying snow caused severe damage to the Kendall Building, as shown in this photograph. While the building and sidewalk took the brunt of the damage, it made the area dangerous for customers. C. D. Kendall bought this corner building in 1903 and operated a drugstore out of the main level for several years. (SDSU Archives.)

Snow removal is always an issue for Brookings residents and city workers, as severe weather is common during winter months. This early-1950s photograph illustrates how the city removed snow from Main Avenue. After piling it up in the middle, a dump truck would come along and pick up the piles, leaving the street clear. (SDSU Archives.)

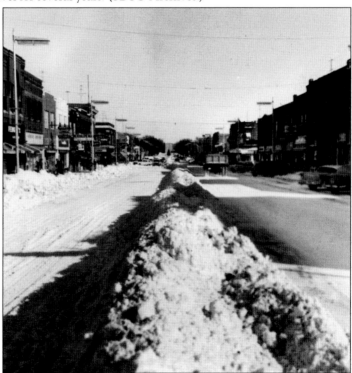

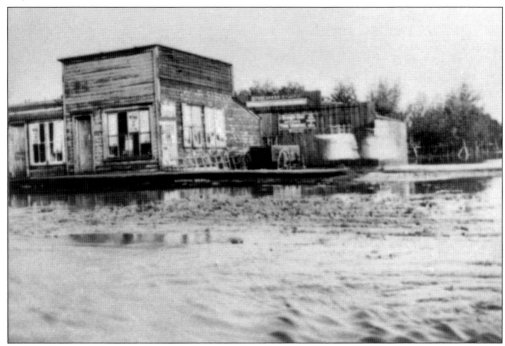

This photograph shows the south side of Fourth Street after a flood in 1896. The dirt street resembles a river. Winters filled with large snowfalls and heavy spring rains often led to flooding in the area. (South Dakota State Agricultural Heritage Museum Photographic Collection.)

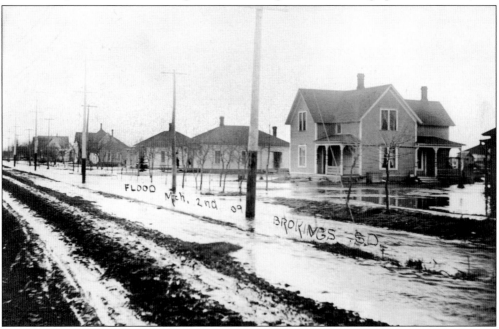

The street and yards of these newly built homes became ponds after a spring thaw in March 1909. City officials were well aware of the flooding issues and worked on getting the streets paved and putting in curbs and gutters to improve conditions. (South Dakota State Agricultural Heritage Museum Photographic Collection.)

Farm animals had a hard time escaping the flooded fields and headed for any dry ground they could find, as can be seen in this early-1950s photograph. Flooded fields often plagued farmers because it often delayed spring planting while they waited for the fields to dry out. (SDSU Archives.)

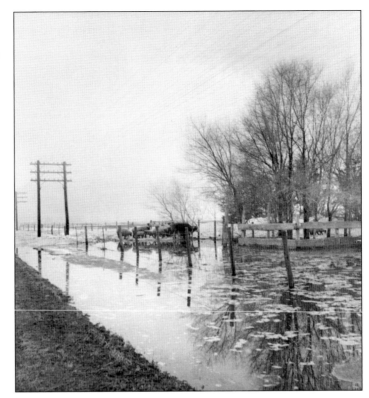

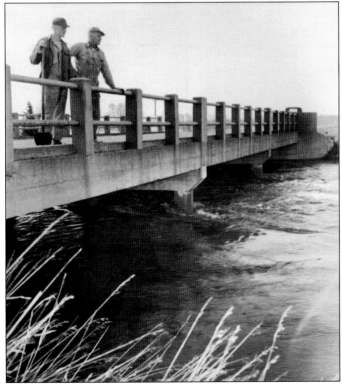

Some local farmers survey the rising river in this April 1952 photograph. Flooding was always a concern for farmers, and these two men were checking to make sure the bridge was still above water. The Big Sioux River often spills over its banks during the spring months, causing severe damage to fields in Brookings County. (SDSU Archives.)

www.arcadiapublishing.com

MAP SEARCH

Discover books about the town where you grew up, the cities where your friends and families live, the town where your parents met, or even that retirement spot you've been dreaming about. Our Web site provides history lovers with exclusive deals, advanced notification about new titles, e-mail alerts of author events, and much more.

MADE IN THE USA

Arcadia Publishing, the leading local history publisher in the United States, is committed to making history accessible and meaningful through publishing books that celebrate and preserve the heritage of America's people and places. Consistent with our mission to preserve history on a local level, this book was printed in South Carolina on American-made paper and manufactured entirely in the United States.

This book carries the accredited Forest Stewardship Council (FSC) label and is printed on 100 percent FSC-certified paper. Products carrying the FSC label are independently certified to assure consumers that they come from forests that are managed to meet the social, economic, and ecological needs of present and future generations.

FSC
Mixed Sources
Product group from well-managed forests and other controlled sources

Cert no. SW-COC-001530
www.fsc.org
© 1996 Forest Stewardship Council

Find Your Place in History.